Owls

The Majestic Hunters

Written and Photographed by
STAN TEKIELA

PUBLICATIONS
Adventure
an imprint of AdventureKEEN

Cover and interior photos by Stan Tekiela except pg. 86 (Barred Owl) by **Lynn A/ Shutterstock.com**; pg. 140 (pellet dissection) by **Agnieszka Bacal/Shutterstock.com**; pg. 138 (Flammulated Owl) and pg. 139 (Northern Pygmy Owl) by **Rick and Nora Bowers**, pg. 4 (owl silhouette) by **DianaFinch/Shutterstock.com**; and pg. 2 (owl silhouette) by **Koshevnyk/Shutterstock.com**. Some photos were taken under controlled conditions.

Edited by Sandy Livoti, Brett Ortler, and Emily Beaumont

Cover and book design by Jonathan Norberg

Library of Congress Cataloging-in-Publication Data
Names: Tekiela, Stan, author photographer.
Title: Owls : the majestic hunters / written and photographed by Stan Tekiela.
Other titles: Intriguing owls.
Description: Second edition. | Cambridge, Minnesota: Adventure Publications, an imprint of AdventureKeen, 2023. | "First edition 2009 (entitled Intriguing owls: exceptional images and insight)."
Identifiers: LCCN 2022055320 (print) | LCCN 2022055321 (ebook) | ISBN 9781647553845 (paperback) | ISBN 9781647553852 (ebook)
Subjects: LCSH: Owls--North America. | Owls--North America--Pictorial works.
Classification: LCC QL696.S8 T45 2023 (print) | LCC QL696.S8 (ebook) | DDC 598.9/7097--dc23/eng/20221116
LC record available at https://lccn.loc.gov/2022055320
LC ebook record available at https://lccn.loc.gov/2022055321

10 9 8 7 6 5 4 3 2 1
Owls: The Majestic Hunters

First Edition 2009 (entitled *Intriguing Owls: Exceptional Images and Insight*)
Second Edition 2023
Copyright © 2009 and 2023 by Stan Tekiela
Published by Adventure Publications
An imprint of AdventureKEEN
310 Garfield Street South
Cambridge, Minnesota 55008
(800) 678-7006
www.adventurepublications.net
ISBN 978-1-64755-384-5 (pbk.); 978-1-64755-385-2 (ebook)

Dedication

For my brothers Ritch, Ken, Matt and David, along with my lifelong friends Matt Mehegan and Joe Giallombardo. We've all come a long way.

Acknowledgments

I would like to thank Peggy Callahan and all the staff at the Wildlife Science Center in Stacy, Minnesota, an independent nonprofit organization dedicated to wolves and all wild animals. I also wish to acknowledge Lee Greenly of the Minnesota Wildlife Connection in Sandstone, Minnesota, and extend my appreciation to The Raptor Center, College of Veterinary Medicine at the University of Minnesota, St. Paul. Special thanks to Karla Kinstler from the International Owl Center in Houston, Minnesota for her outstanding technical review of this book. Her input truly polished the text.

Thanks!

Contents

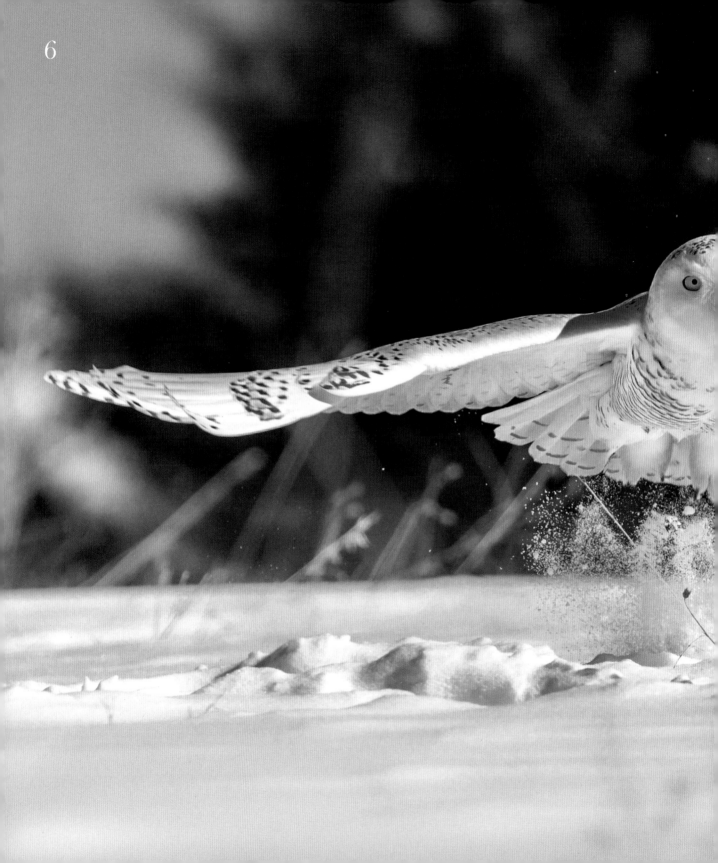

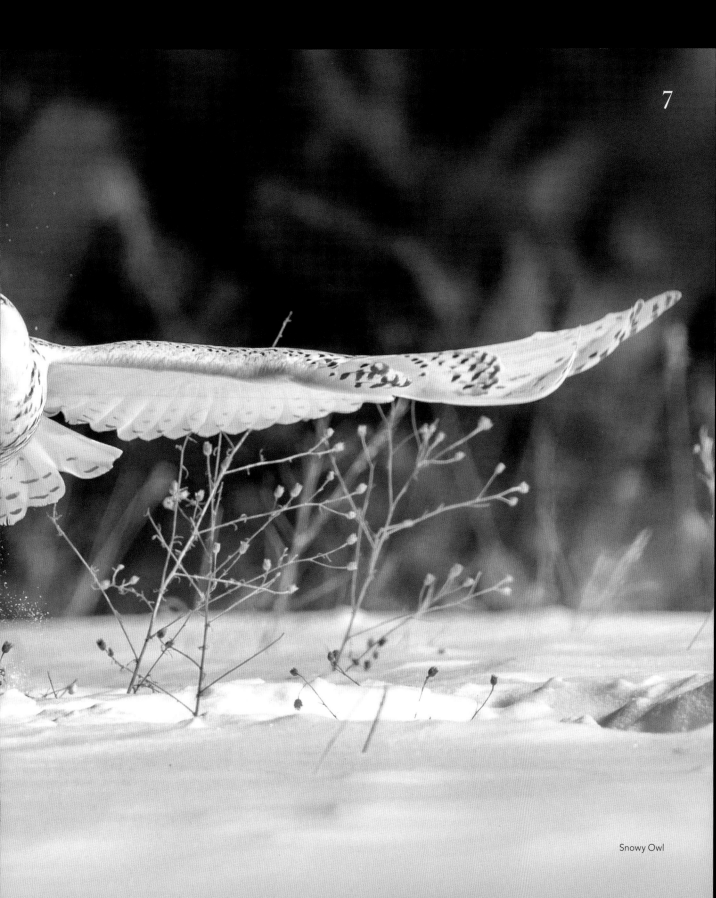

Snowy Owl

Intriguing owls

Owls have intrigued me ever since I became fascinated with birds. Mysterious birds of prey with interesting behaviors and large eyes, they appear to have great intelligence. Owls hunt when people can't see them—under the cover of darkness, creating even more intrigue. Like the wolf and mountain lion, owls are top predators and command our respect. While I continue to enjoy birds of every shape, color, and size, I invariably search out the owls to study and photograph. Here is their extraordinary story.

Stan Tekiela

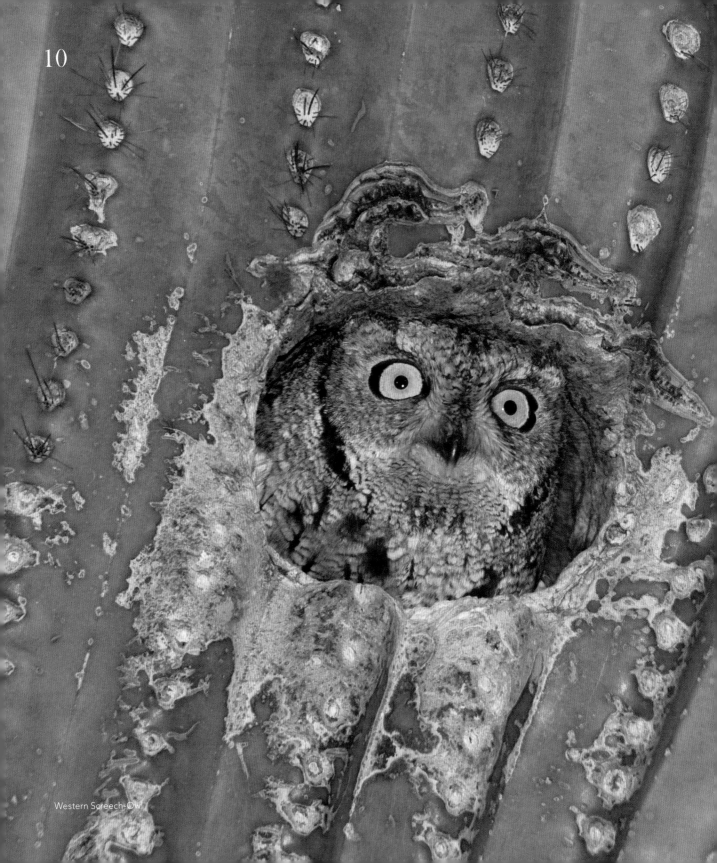

Western Screech-Owl

The owl family

Owls are widespread around the world, with the exception of a few places such as Antarctica and some small isolated islands. While many people mistakenly believe that owls are Northern birds found only in cold and snowy latitudes, over half of the world's owls actually occur farther South, in tropical and neotropical regions. Of all the nearly 11,000-plus species of birds in the world, less than 3% are owls, but that's still roughly 250 wonderful owl species for us to appreciate and admire.

All owls are members of a group, or scientific order, called Strigiformes. Strigiformes is separated into two distinguished families—Strigidae and Tytonidae. Strigidae includes typical owls such as the Barred Owl. The family Tytonidae, consisting of barn owls and other types, includes the aptly named Barn Owl.

Species diversity

There are 19 owl species in the United States and Canada. An extremely diverse group, these owls range in size from the tiny Elf Owl to the hefty Snowy Owl. About the size of a sparrow and sporting a 13-inch wingspan, the Elf Owl is the world's smallest owl, weighing just under a dainty 1½ ounces. The Great Gray Owl is our tallest owl, standing 27 inches tall and weighing 2½ pounds. The Snowy Owl is the heaviest owl in North America and the second tallest. It has an impressive wingspan of 4½–5 feet, weighs over 4 pounds, and stands 23 inches tall.

The remainder of our beloved owls fall within these extremes. The Eastern Screech-Owl often lives in our backyards, making its home in natural cavities or man-made wooden nest boxes. The dark-eyed Barred Owl entertains us in the evening with its raucous calls. While the Barn Owl takes up residency in our barns and other out-buildings, the Great Horned Owl—the most common of all North American owls—can be found in nearly any habitat, from deserts and forests to the seaside and mountains.

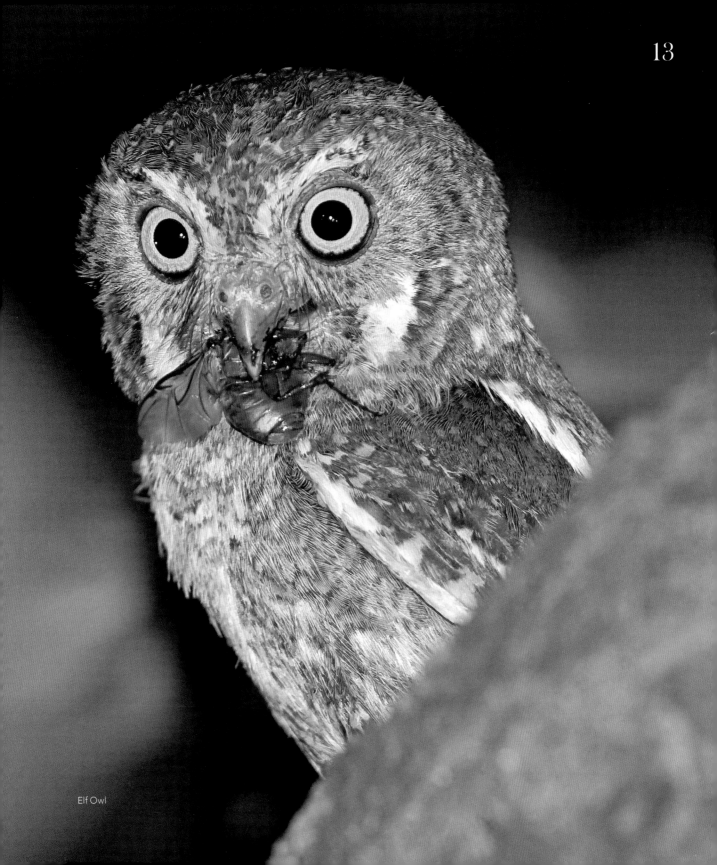

Elf Owl

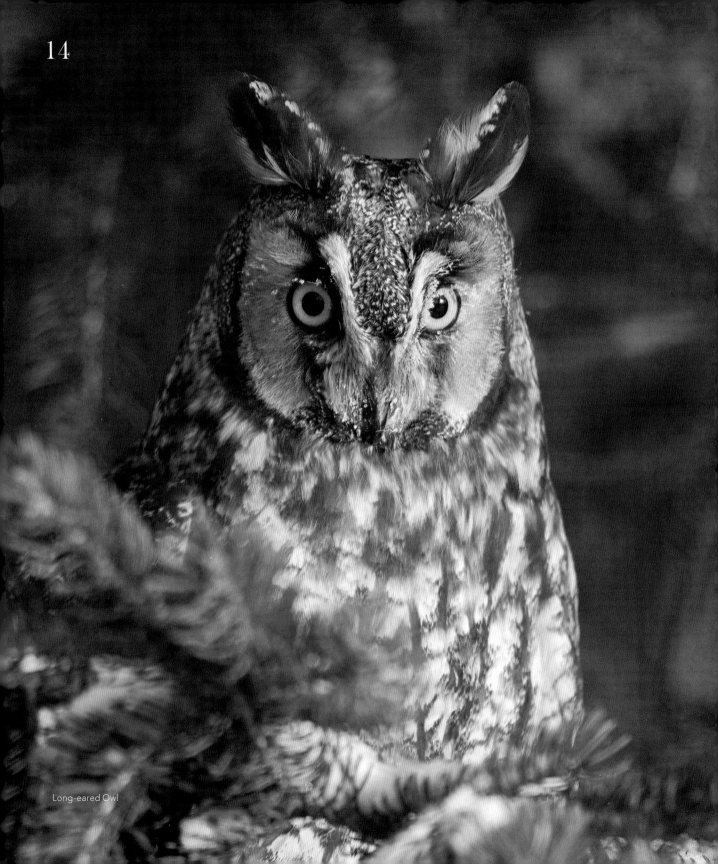

Long-eared Owl

Owls from coast to coast

Every state in the country has at least two to three owl species. Distribution is uneven from East to West, and the number of species increases going West.

Northeastern states, including New England, have six to seven species, with the Barred Owl and Great Horned Owl being fairly common.

Excluding Florida, Southeastern states are home to four to five species, among them the Eastern Screech-Owl and Barn Owl. Florida and Midwestern states as far west as Nebraska and the Dakotas host six to seven species. The upper Midwest also has six to seven species, with the famed Great Gray Owl and Snowy Owl making their appearances during the winter months. In the far Northwest, Alaska has at least seven species that include the Northern Hawk Owl and Short-eared Owl.

The species number jumps to eight or nine in Western states such as Idaho, Colorado, and New Mexico. Southeastern Arizona, home to the Elf Owl and the extremely uncommon Ferruginous Pygmy-Owl, has 10 species, as do eastern Oregon and Washington—all of which are resident states of the Northern Saw-whet Owl and Burrowing Owl.

Western Oregon, Washington, and much of California have the highest diversity of owls, with a total of 11 species, including the Long-eared Owl and Western Screech-Owl. Most of the species living in these states are also found in the Eastern United States.

Origins of the species

For nearly 200 years it was thought that owls were related to raptors—carnivorous predatory birds, such as hawks, eagles, and falcons, that feed on animals. In the late 1750s, Swedish botanist Carolus Linnaeus decided that owls (with their curved bills, sharp talons, and ability to hunt and kill) did indeed look and act like raptors, so they were all classified in a scientific order called the Accipitres. However, others argued that owls were actually more like nightjars—nocturnal hunting birds, such as the Common Nighthawk and Whip-poor-will, with large, round heads; large eyes; and downy plumage. We now know that owls are not related to the nightjars.

Recent DNA studies show us clearly that owls are related to daytime flying raptors such as hawks. They are closely related to the Accipitrimorphae (daytime hawks).

Our own unique traits make it easy to respect the complexities present in owls and all forms of life. While the scientific debate persists and technology improves, we can continue to hold owls and their amazing intricacies in high regard.

Snowy Owl

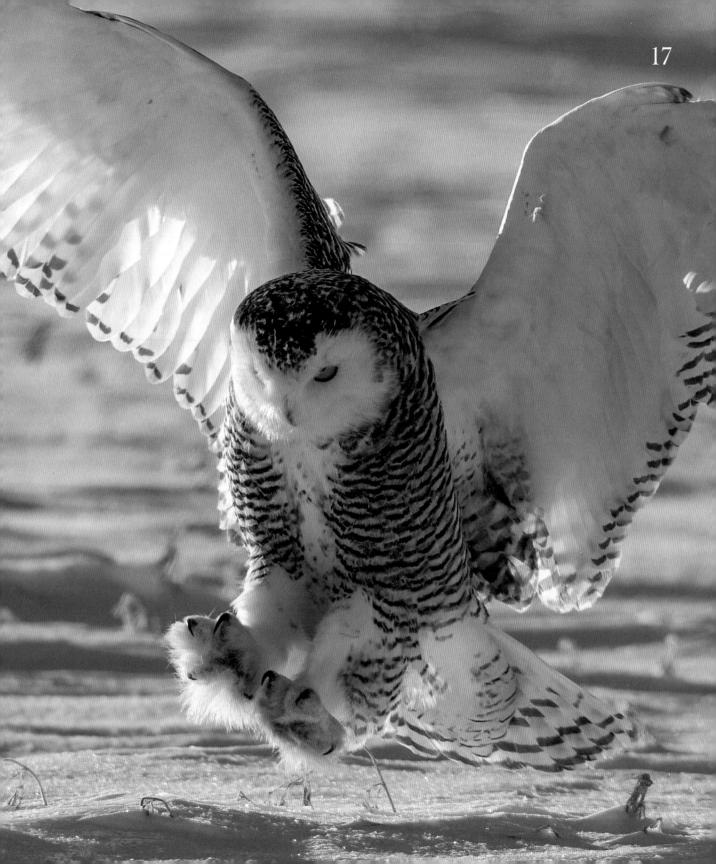

Northern Hawk Owl

Life span

In general, the larger the bird, the longer it lives. Tiny hummingbirds, chickadees, and other small birds live an average of only three to five years. Those reaching 8 years old are considered both ancient and exceptional. The Bald Eagle and other large birds survive 25–30 years, but the age champion is the California Condor, with some individuals reaching 70–75 years. Since owls vary widely in size, longevity depends on the species. While some have a life span of 10 years, others live as long as 20–25 years.

The most dangerous time of an owl's life is its first year—the time when fully 50% of all young hatchlings perish. Starvation and sibling competition take the lives of many weak young owls before they can make it out of the nest. Of those that manage to leave, many do not survive. The process of learning to fly, hunt, and defend is very difficult, so even more young owls die during this time.

Of the strong, smart, and fortunate young that actually make it beyond the first year, various hazards, such as collisions with vehicles and illegal shooting and trapping, threaten to destroy them. In addition, larger owls will sometimes kill and eat smaller owls. If this weren't already enough, winter can shorten an owl's life span. In parts of the country with cold and snowy winters, some owls can't find enough to eat under a thick blanket of snow and end up starving to death.

Unique adaptations

Just one look at an owl will convince most people it is a very special bird. Perhaps no other single feature defines an owl more than its eyes. Owls have huge forward-facing eyes and human-like eyelids that blink from the top down, giving them the appearance of being smart and alert. This is unlike other birds, which have eyes on the sides of their heads and eyelids that blink from the bottom up. In owls, the lower lid goes up only during sleep.

The head of an owl is also remarkable in that it is round and much larger in proportion to its body than it is in other birds—this correlates to its front-facing large eyes. In many owl species, just one of the eyes takes up about as much space in the skull as its brain.

Another unique characteristic in owls is the facial disk. Facial disks act like satellite dishes, gathering sound and funneling it to the ears, which are on the face, usually just below and behind the eyes. Large and obvious in some owls, such as the Boreal Owl and Northern Saw-whet Owl, and much less noticeable in others, facial disks are so important that many owl species have misshapen (asymmetrical) skulls to accommodate the feature.

Eastern Screech-Owl

Body in camouflage

All owls have barrel-shaped bodies. This physique is due to the large flight muscles in their chests that are necessary for the strong, fast flight needed to capture prey. Nearly all owl species are feathered in camouflage colors of brown, black, or gray, with small amounts of white. Concealing coloration allows the birds to blend into their environment during daytime inactivity. Just as a white Snowy Owl blends well into a snowy setting, a Barred Owl can be easy to miss when it's perched on a tree branch.

Toes and talons

The feet of owls, like those of raptors, set them apart from other birds. Large, powerful feet and toes with long, pointed nails, or talons, make up the business end of all owl species. Owls use their feet to capture, hold, and sometimes kill prey. To fend off attacks from desperate prey, owls protect themselves with their toes and talons. Because an eye injury could be a death warrant to an owl, great care is taken when prey is up close, personal, and struggling. With the prey grasped securely, owls can safely dispatch it with a bite to the neck, severing the spinal cord.

Heavyweight eyes and 24-hour sight

Eyesight is so important to owls that, in some species, the eyes are disproportionately large. In Eastern Screech-Owls, the eyeballs weigh about ¼ ounce, which is nearly 5% of its entire body weight. In contrast, human eyeballs weigh slightly more—roughly 1 ounce—but this is only a minuscule fraction of a person's total body weight. Great Horned Owls have some of the largest eyes of all owls in the United States. Their eyeballs are about the size and weight as our own, but if our eyes were in the same proportion to our bodies as the Great Horned Owl's, they would be the size of tennis balls or larger.

Many people believe that owls are blind during the day and have the ability to see in complete darkness. Both of these assumptions are incorrect. Although owls have excellent eyesight in dim light, they also can see well during the day, even in bright sunlight.

Great Horned Owl

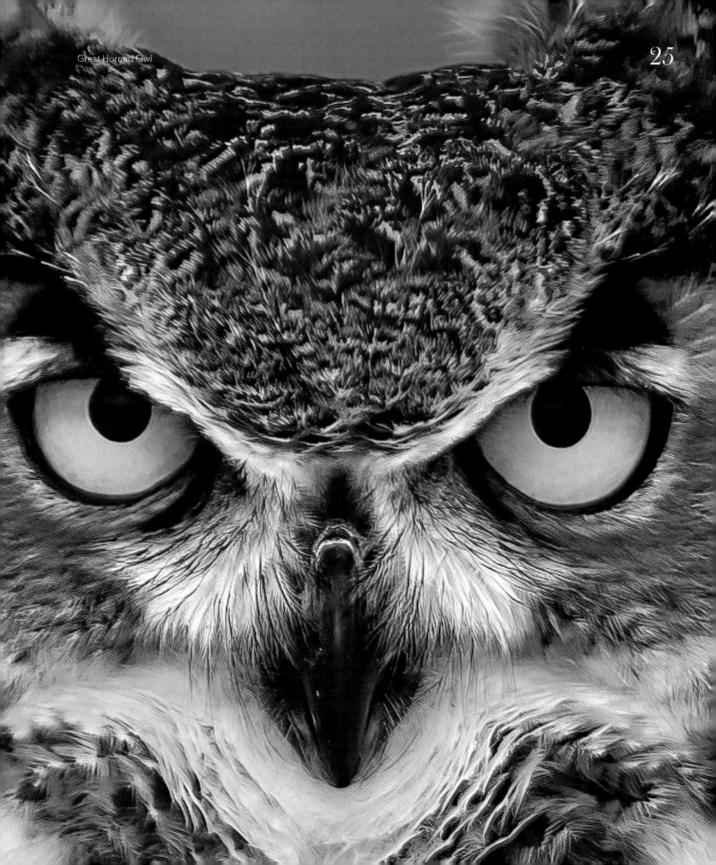

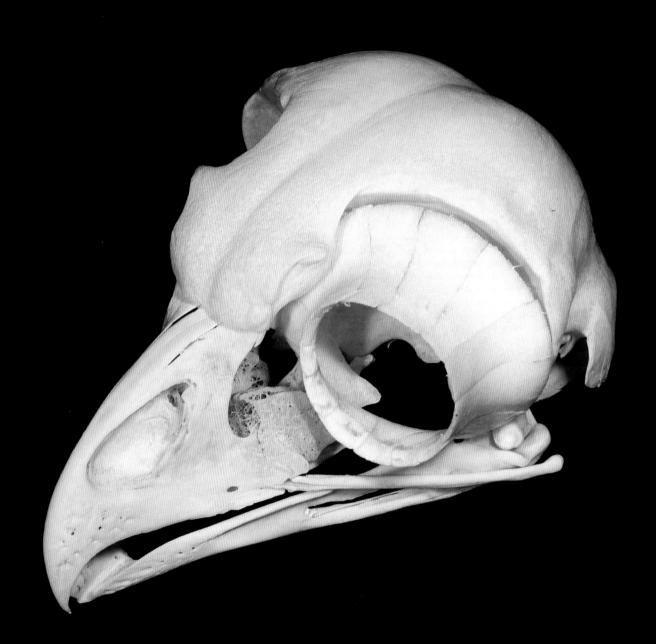

Great Horned Owl

Acute eye power and built-in protection

Owl eyes may look human, but when the eyeballs are removed from the head for examination, they are quite different. Besides being larger, they are tubular in shape, not round. A tubular shape allows for more distance in the eye from front to back (focal length)—which is important because the greater the focal length, the larger the image will be on the retina. An image projected in the tubular eyes of owls is much larger than it would be in other birds that have round, flattened, or disk-shaped eyes on the sides of their heads. This gives owls a distinct advantage akin to having a built-in telephoto lens when it comes to seeing small objects such as mice.

Structurally, the eyes of owls and other birds are similar to those of reptiles. Owls have a large sclerotic ring—a circular structure surrounding each eye made up of anywhere from 10–18 flat bony plates, depending on the species. These bony rings support the eyes and encircle the lenses. The eye muscles, or ciliary muscles, attach here and provide the ability to focus an image on the back of the eye, using the lens in the front of the eye. The more ciliary muscles a species has, the faster and more accurate the focus.

Low-light vision

Eyes function the same way in owls and humans during daylight but differ when light is dim. The light-sensitive iris constricts or expands to control the amount of light going through the pupil—the dark part of the eye. While constriction is comparable in owls and people during the day, dilation is greater in owls when light is low. As a result, up to 2½ times more light can enter their eyes, enabling them to see 2½ times better than we can in the dark. Compared with nonpredatory birds, owls have over 100 times more low-light sensitivity, giving them their highly superior vision.

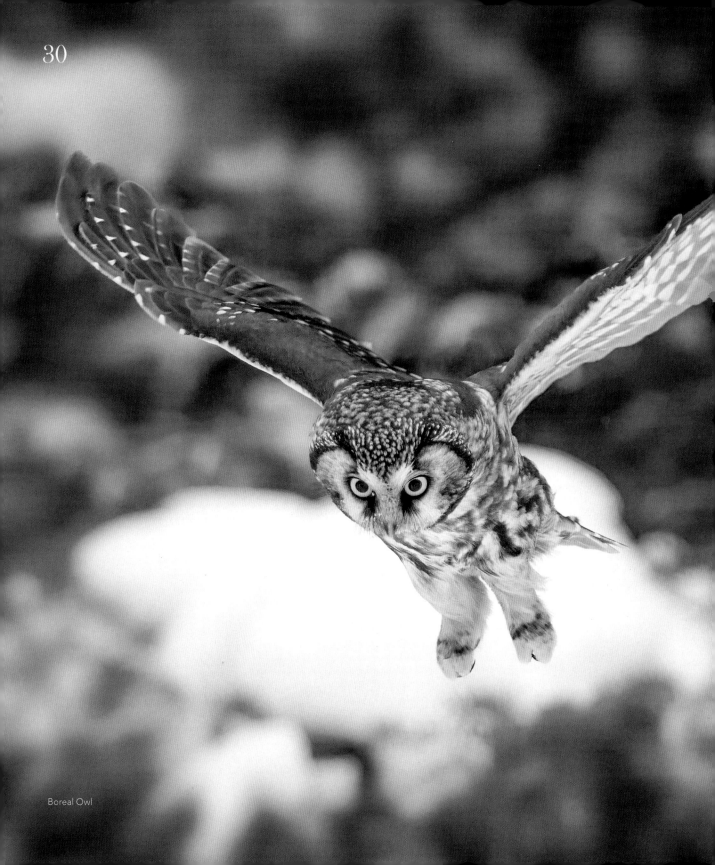

Boreal Owl

Binocular viewing

Like people, owls have binocular vision. This simply means that both eyes are in the front of the head and face forward, like a pair of binoculars. Binocular vision equips owls with a large field of vision, up to 110 degrees, and is extremely important because it gives them a sharp edge in their ability to maneuver around obstacles such as tree trunks and branches when flying. It is also essential for depth perception, which is what allows owls to accurately judge distances when hunting and helps them pinpoint small prey.

Owls also have a wide field of vision, with the ability to see 110 degrees without moving their heads. Of that, 70% is binocular. We can see a range of 180 degrees when we move our eyes. Of that, 80% is binocular. While the owl vision field seems narrower than ours, extra neck vertebrae allow them to swivel their heads, resulting in a wider range of vision than people enjoy.

Songbirds, game birds, and other nonpredatory birds with eyes on the sides of their heads have panoramic vision. Without moving their heads, they can see a full 360 degrees, including the sky. While panoramic vision enables these birds to see predators in all directions, they lack the depth perception of owls.

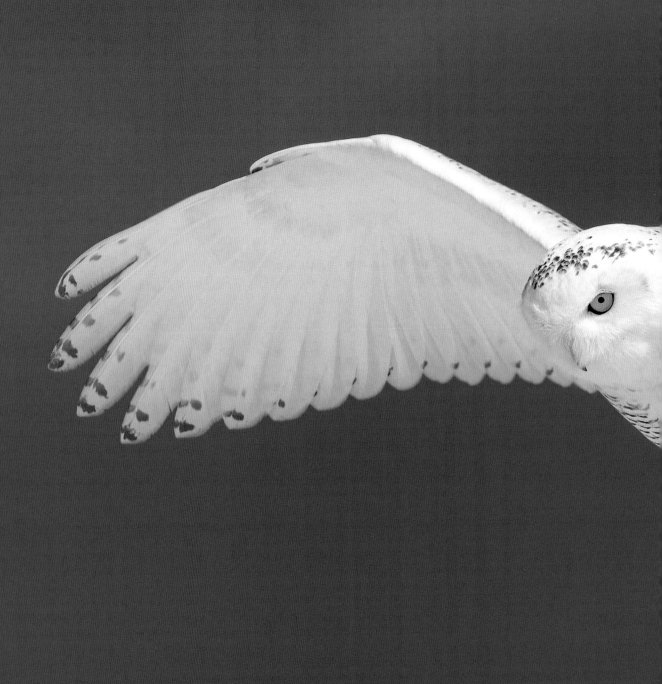

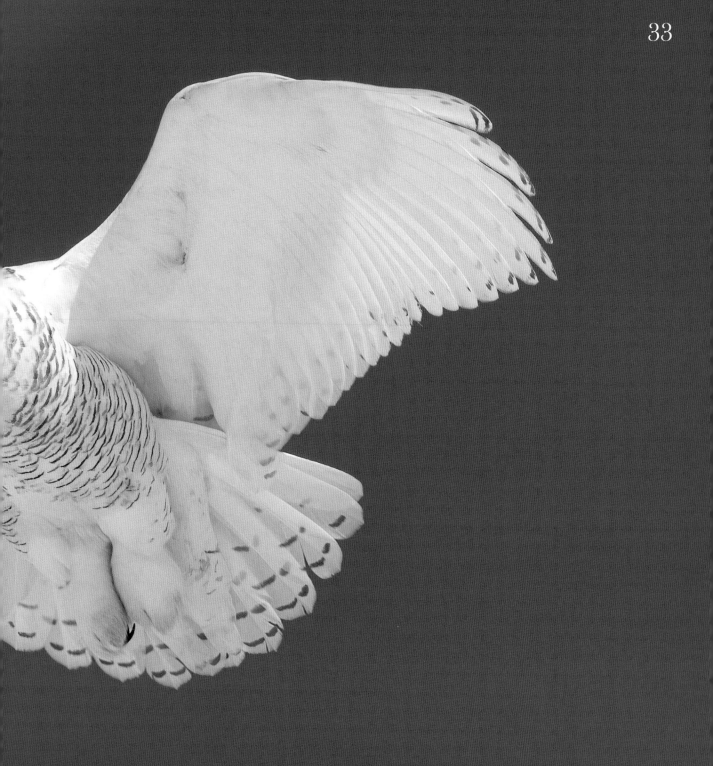

Snowy Owl

Spotted Owl

Red-eye reduction

Most of us have seen a pair of animal eyes glowing yellow, green, or blue after dark, usually reflected by our vehicle headlights. The radiance is caused by a highly reflective layer at the back of the eye in the retina called the tapetum lucidum, which means "bright curtain" in Latin. This layer catches any light that has slipped past the light-receiving rods and cones and bounces it forward again, providing a second opportunity for these receptors to capture the light, increasing an animal's ability to see in low light.

Owls do not have this reflective layer. When a camera flash or other light shines into their eyes, it bounces off a layer of blood vessels located at the rear of the eye, which reflects a luminous red. Unlike animals with the tapetum lucidum, the lack of it in owls has no effect on their vision in low light.

Head rotation

Having large eyes is a great advantage for owls, but oversize eyes have some limitations. Owl eyes are so big that there is actually no room left in the sockets for the eyes to move. While our eyes move freely in their sockets, allowing us to see side to side and up and down without moving our heads, an owl's eyes are fixed. Consequently, owls must move their heads to see anything not directly in front of them.

The neck of an owl has 14 bones (vertebrae). This is twice as many neck bones as in people and is the reason why owls have more mobility of their heads. Owls can rotate their heads 280 degrees without shifting their body position, giving them a wide range of vision. They cannot turn their heads all the way around to a full 360 degrees, as some people believe. Once an owl reaches its physical limit in one direction, it rotates its head back around the other way to pick up the sighting where it left off.

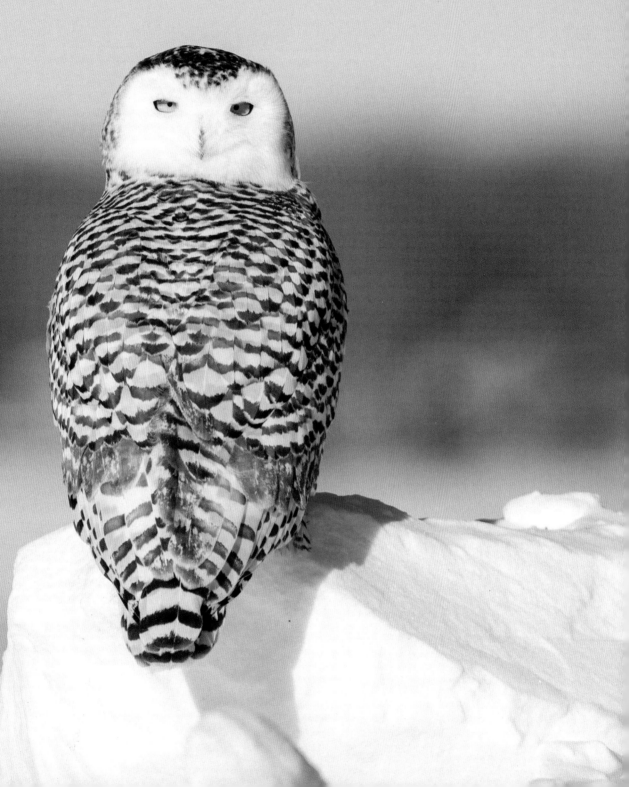

Barn Owl

Head bobbing

Many owl species bob their heads in peculiar, funny-looking ways. Some can even turn their heads completely upside down! Although these maneuvers might make an observer smile, the behavior is strictly functional. Head bobbing is a technique used by owls to help improve their vision. Observed in owls as young as a few days old, head bobbing helps the birds sight an object and bring it into focus.

When an owl views something, the image is reflected onto a specialized thin spot at the back of the eye called the fovea. The fovea has light-gathering receptor cells concentrated in a funnel-shaped pit and is the area of maximum resolution, or sharpest vision. To see an object beyond the field of vision, such as a squirrel nest overhead, an owl must move its head to maneuver the image directly onto the fovea. As the head moves, it swings the image of the object back and forth across the fovea, producing greater clarity and, some believe, more detail.

Bills in bristles

Bills in owls tend to be somewhat shorter and more downward sloping than in other raptors. In many species the bill is mostly hidden by specialized feathers called rictal bristles. Rictal bristles are long and hair-like and extend down the sides of the bill to form a mustache, creating a human-like appearance.

The purpose of bristly feathers is not well understood, but they are probably easier to clean and maintain than regular feathers. Also known as tactile bristles, they may also help owls to touch or sense objects that are too close to see. Some species have extra-long tactile bristles surrounding their facial disk. These might serve to transmit more information to a hunting owl by picking up vibrations in the air, acting similar to hearing.

The bite

Unlike hawks and eagles, most owls don't tear up food that can be swallowed whole. Only large prey items are torn into bite-size pieces. Most owls have smaller, less powerful bills than hawks and eagles, but this does not mean that their bills are undersized or fragile. Bills of large owls, namely Snowy Owls and Great Horned Owls, are impressive at roughly 1½–2 inches. Some species, such as the Elf Owl, have tiny, sharp bills—the perfect equipment for eating their primary food, insects. In all owls, bill tips and edges are extremely sharp and easily tear through prey. Owl parents use their bills to tear up the small portions needed to feed their young.

Once prey is caught, an owl will dispatch it with a bite to the base of the head, cutting or crushing the spinal column. This single action could be the most important role of an owl's bill.

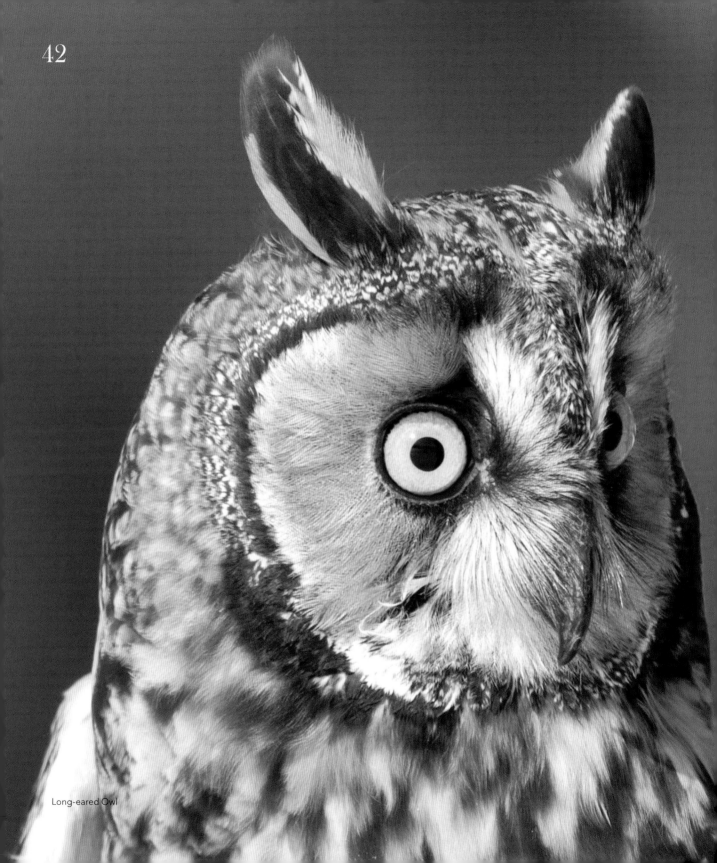

Long-eared Owl

Horns and ears

Many owl species have tufts of feathers on top of their heads that look like ears or horns. This distinguishing feature is often referenced in common names such as Long-eared Owl and Great Horned Owl. However, the feather tufts, or ear tufts, are neither ears nor horns. An owl's ears are actually on its face just below and behind the eyes, hidden beneath feathers. The size of the ear opening varies among species, as does shape, which ranges from round to oval.

Split-second hearing

Most owl species have asymmetrical ear openings—one is slightly larger than the other or is higher up on the skull. Asymmetry is less pronounced in Great Gray Owls and other daytime (diurnal) hunters than in those active at night (nocturnal).

Differing ear-opening sizes and positions allow owls to locate prey with pinpoint accuracy. Irregular openings permit sound to reach the closer ear first, allowing an owl to localize the sound and lock onto the position of prey—even when it is hidden. Owls are legendary for their keen hearing, and scientific studies have shown that owls can differentiate the timing of a sound reaching each ear to about 30 millionths of a second!

Where is that sound?

While stars, the moon, and other sources of light prevent the night from being pitch dark, this hasn't kept researchers from testing the ability of owls to hunt in total darkness. To find an object in complete darkness, its location must be identified by the sound it makes on two planes, the horizontal and vertical.

Most owls can pinpoint a sound in front of them to within 1–2 degrees. On a horizontal plane, this is about the same as people. Owls perceive the height of a sound, or the vertical plane, by tilting their heads from side to side up to 90 degrees. Head tilting exaggerates the asymmetrical ear positions even more and provides additional clues as to the origin of a sound. In complete darkness, owls can pin down a sound vertically to within 1–2 degrees. It is along the vertical plane where people differ from owls and fall far short in their hearing abilities.

Combining sounds from horizontal and vertical positions is like looking at the crosshairs of a scope, and it gives owls an accurate sense of the exact location of an object. In a light-free laboratory, Barn Owls using their hearing alone to hunt were successful about 90% of the time.

ear canal →

← ear canal

Great Gray Owl

Barn Owl

Ear flaps and facial disks

Each ear opening of an owl has a skin flap (operculum) that is covered with short, densely packed, highly specialized feathers. Owls adjust their opercula to direct sound into their ears and also to keep unwanted noise out. Owls will close both ear flaps so they can get some sleep and avoid being constantly bombarded with loud sounds all day long.

A facial disk forms the shallow, saucer-like depressions on the face of an owl. Extending from the forehead to below the bill, facial disk shape varies among the species. For example, round facial disks occur in Great Gray Owls, while Barn Owls have heart-shaped disks. Disks of any contour are vital in focusing and funneling sound to ear openings, positioned near the back of the disk. The distinctive shape and function of facial disks is achieved by highly specialized feathers, not skull structure, as one might think.

Disk feathers and facial expressions

Facial disks have highly specialized feathers that look more like long, thin bristly or fuzzy hairs. The feathers at the outer edges of the disk are more tightly packed and much longer than those forming the interior of the disk. In some species, rim feathers are a different color and form an outline of the disk.

Feathers within the disk are shorter, densely packed, and transmit sound directly to the ear openings. While it seems logical to think that densely packed feathers would decrease sound transmission, they actually help transmit sound. In one laboratory study, owls hunting in complete darkness with trimmed disk feathers were less successful at catching mice than those without disk feather alteration.

While the skull of an owl is disproportionately large, it is the long head feathers that create the puffy-looking appearance. Both the skull size and long feathers are thought to enhance the sound-gathering ability of the facial disk.

To perceive even the faintest of sounds, owls use their muscles to adjust the position of their disk feathers. By controlling the size and shape of the facial disk, owls are able to change their facial expressions. In addition to improving hearing, this ability may also allow owls to convey emotions to mates, offspring, parents, and other owls.

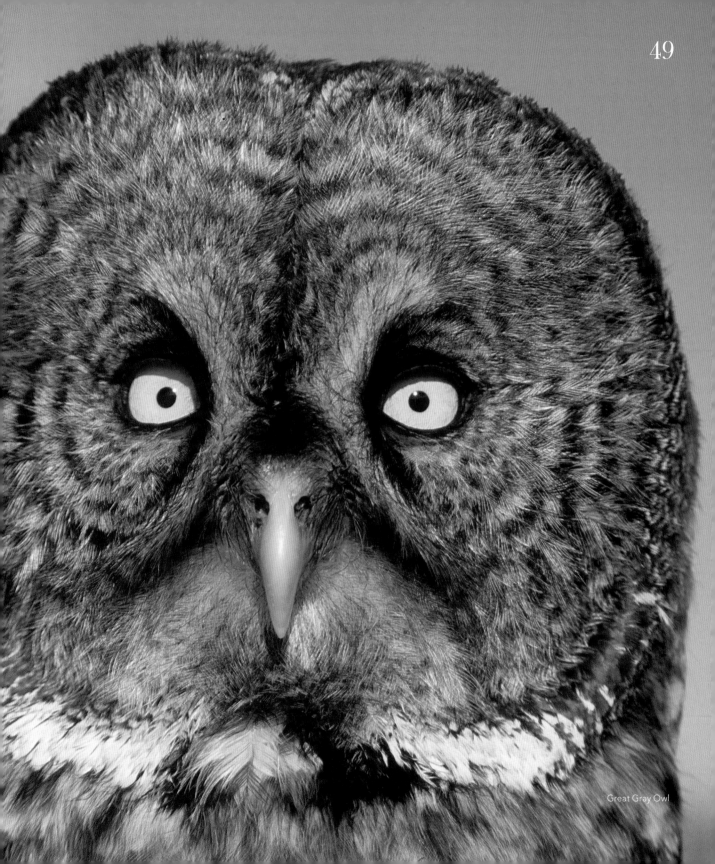

Great Gray Owl

Owl size

In general, the size of an owl correlates with the size of its prey. Larger owl species take larger food items, and smaller owl species eat smaller prey. In addition, species of about the same size tend to consume the same kinds of things. The petite Elf Owl and other small owls, such as Burrowing Owls, eat mainly insects, which provide great nutrition and fat. Medium-size owls, such as the Spotted Owl, prefer woodrats and larger mice. Large Snowy Owls often hunt rabbits and hares, which are nearly equal to the Snowy in weight. Larger owls often eat smaller owls, but this is an opportunistic behavior since bigger owls will take any smaller bird when it is available, owl or not.

The smaller the owl, the more time it spends hunting. On average, small owls need to consume around 50% of their body weight each night. The largest owls require only about 15% of their body weight per night. Screech-Owls and other small owls expend more energy and time hunting common food sources such as insects. Larger owls, such as the Great Horned Owl, can tolerate daily fluctuations in their diet because one to two larger prey items will keep them full for at least an entire night.

In North America, an owl's size is often closely related to the latitude of its home. Generally, the larger the owl species, the farther north it lives. Large owls, such as the Snowy Owl and Great Gray Owl, reside in cold and snowy northern locales. Smaller owls, such as the Ferruginous Pygmy-Owl and Elf Owl, prefer much warmer climates farther south. Some people mistakenly attribute the size and geographical distribution to Bergmann's Rule, which states that the body mass of birds and animals changes with the latitude, but Bergmann's Rule applies only to individuals within a species, not across groups, as seen in owls.

Differences of the sexes

In many bird species, males and females are sexually dimorphic—they look different from each other. The Northern Cardinal is a good example of sexual dimorphism—males are bright red and females are a dull brown.

In almost all owls, the male and female of a species have identical feathering, as seen in the Burrowing Owl. Slight differences in plumage are evident in some species, such as the Barn Owl. Male Barn Owls have a white face, chest, and belly, while females have a tawny face, with a spotted chest and belly. In Snowy Owls, males tend to be nearly all white, stippled with only very small black markings. Females are more heavily mottled with black.

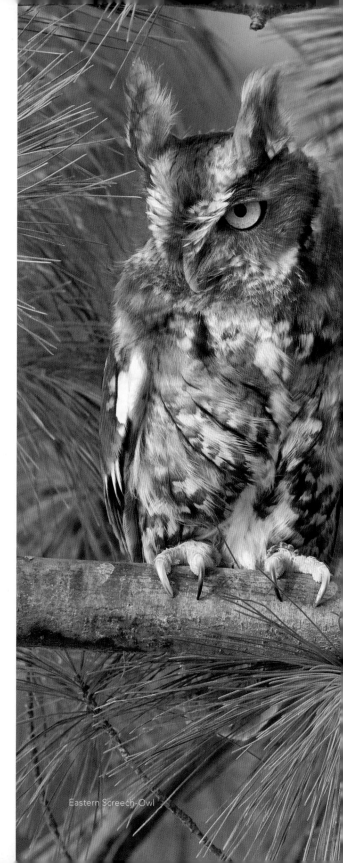

Eastern Screech-Owl

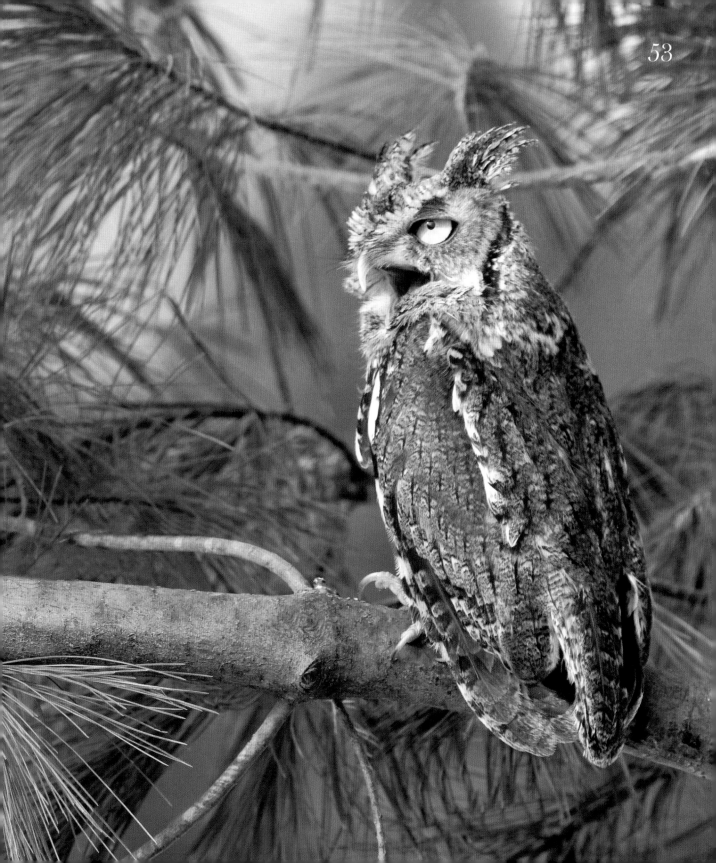

Burrowing Owl

The main difference between male and female owls is that, in nearly all species, females are 10–30% larger than males. This size difference is called reverse sexual dimorphism, which in owls is opposite from the sexually dimorphic mammals, where males are larger than females.

It's not exactly clear why owls exhibit such a size discrepancy, and the issue has been debated for over a century. Charles Darwin argued that sexual dimorphism in mammals is the outcome of sexual selection, which simply means that because larger males win the fights for mates, their genetic code for large size prevails. In owls, the case for sexual selection is reversed to favor larger females. It is thought that larger females produce more eggs, ensuring continuation of the species. In addition, the larger female body mass would be better able to successfully incubate eggs during cold weather. Larger females are also more formidable defenders of eggs or young when the males are off hunting.

Conversely, the smaller male counterparts are more agile and fleet, which are useful abilities for courtship displays and hunting. Since the males are the main supplier of food not only for the young, but also for the female while she incubates and after the young hatch, it may be possible that female owls did not actually get larger. The males might just have become smaller.

Slimming to trim

Different sizes in an owl pair may not always be obvious, especially if the male and female are not sitting side by side. When researchers band owls, they measure weight to help determine the sex. Weights of female owls are in a different, heavier range than the weights of the males. Since females are heavier, they can afford to lose weight more than their smaller male partners. The females often do lose weight, actually starving themselves while feeding their young. Through partial starvation, a mother owl ensures that her young chicks get enough to eat.

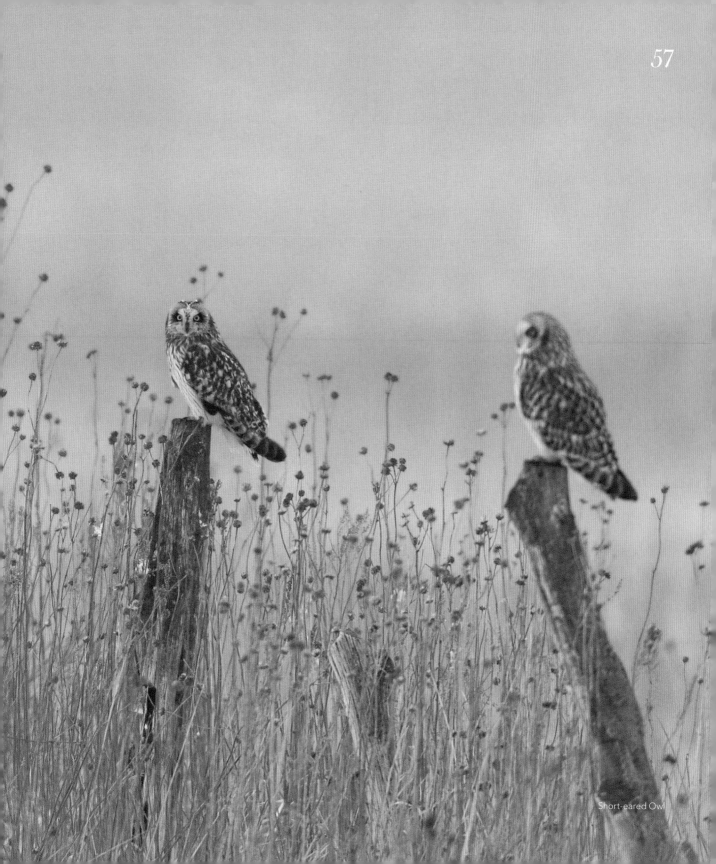

Short-eared Owl

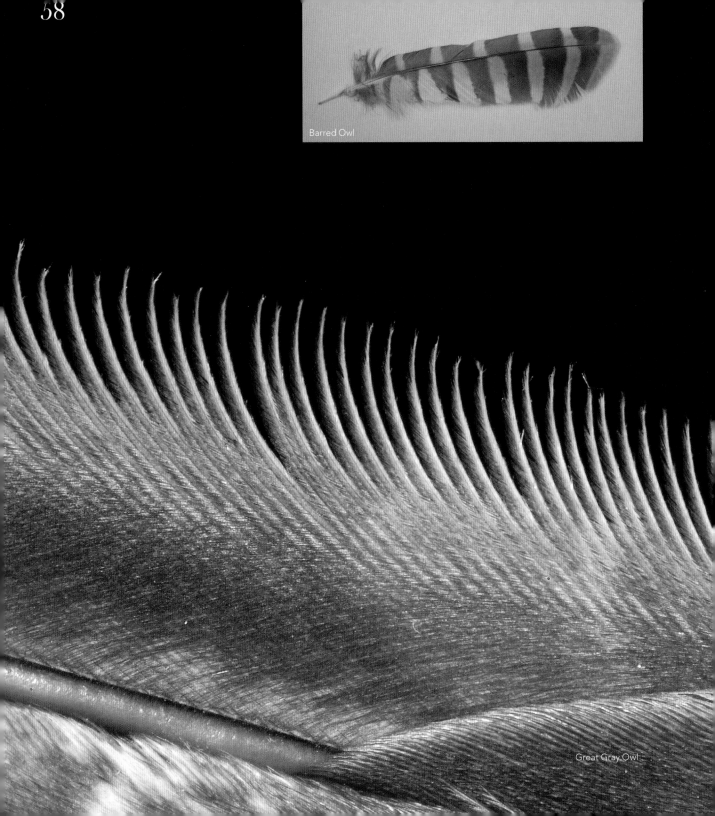

58

Barred Owl

Great Gray Owl

Silent flight

Feathers are quite simply unique. They are a vital part of what makes a bird and differentiates it from other creatures. Owl feathers are distinctive, even among birds. When woodpeckers and other birds fly, their wings greatly disturb the air, causing noisy turbulence. Most owl species have extraordinary, specialized flight feathers that don't disturb the air as much, muffling the noise, allowing for silent flight.

Some primary flight feathers in owls have a comb-like rigid structure along the leading edge. In addition, the trailing edge and the tips of the flight feathers are trimmed with a hair-like soft fringe. Presumably, both stiff and soft fringes work together to muffle or reduce air turbulence and diminish flight noise.

In addition, owls have fine, hair-like down on the upper surface of their primary and secondary flight feathers, near the base. This soft down pile cushions flight feathers against each other, reducing rubbing and greatly decreasing the sound feathers make during takeoff, flight, and landing.

All of these exceptional features permit owls to fly with stealth and are a key reason why they are such efficient predators. Fringe and down pile are well developed in Boreal Owls, Northern Saw-whet Owls, and others that hunt small animals at night—the dark time when keen hearing and quiet are needed to catch hidden prey moving under leaves or snow. Attributes of silent flight are less evident in Ferruginous Pygmy-Owls, Elf Owls, Northern Hawk Owls, and others that locate insects by eyesight or that hunt other prey during the day.

Silent flight is not only great for sneaking up on prey, but it also enables owls to hear sharply while flying, resulting in more effective hunting. Imagine a mouse scampering under inches of leaves or hiding in a blanket of snow. A perching owl will cock its head slowly from one side to another to aid hearing, lock onto the location of the sound, and leap from the perch. If its wings made the typical whirring, whooshing, or humming noises similar to the sounds other birds make in flight, the owl would lose track of its prey amid the noise of its own wings and would be a less efficient hunter.

Northern Hawk Owl

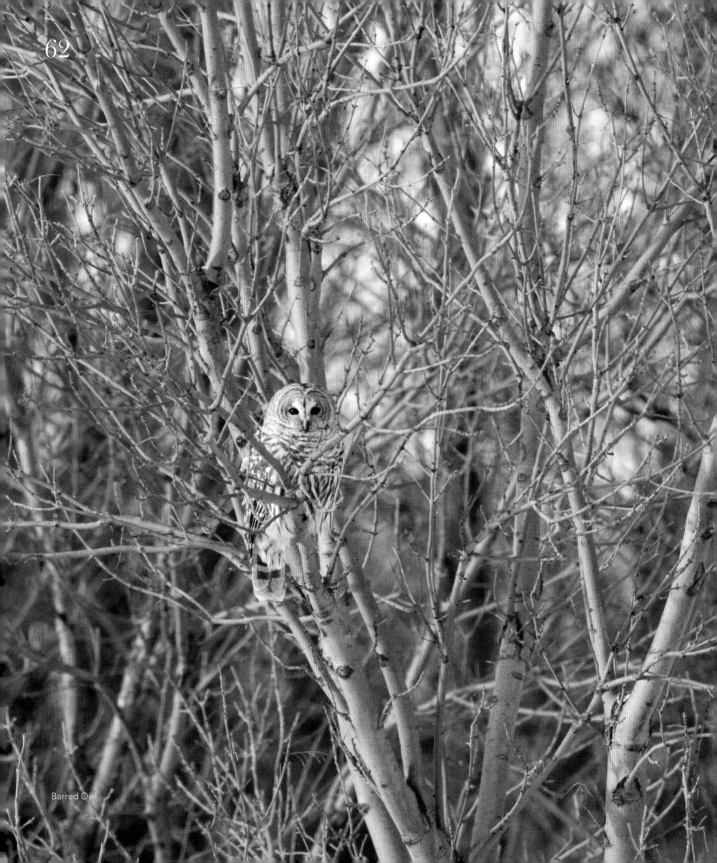

Barred Owl

Equipped to conceal

The feathers of nearly all owl species are some shade of brown, black, gray, or white. These colors help hide owls from crows and other aggressive birds that band together and attack in mobs during the day.

Owls are concealed by their colors in several interesting ways. Camouflage coloring matches the earthy colors and patterns of tree bark, wood, rocks, sand, snow, and more, giving owls the ability to blend in with their natural environment. Disruptive design uses dark marks, streakings, and tan-to-white spotting to obscure the bird's silhouette. Countershading is an arrangement of lighter colors on the underside and darker feathers on the back, helping to counter the effects of a shadow when an owl is perched.

Striking a pose

Worldwide, about 40% of all owl species—and roughly one-third of the 19 owl species in the United States—have ear tufts. It is thought that ear tufts help to hide owls by fragmenting the outline of the body or by simulating the broken top of a tree branch. With ear tufts and camouflage coloring, an owl can melt into its environment and go undetected during the day.

To support this idea, researcher Denver Holt and colleagues observed captive "eared" owls in the presence of a domestic cat and a larger predatory species such as a falcon. When danger was at hand, the owls raised their ear tufts and constricted their body feathers to appear thinner and taller, like a branch. Some owls actually swung a camouflage-colored wing in front of themselves to hide their bodies even more!

This type of positioning is called concealment posture. The Long-eared Owl is well known for it, as well as for striking a pose against a large tree trunk. It does this judiciously, however—only to remain unseen when a predator stalks nearby or to avoid being mobbed by other birds.

Eastern Screech-Owl

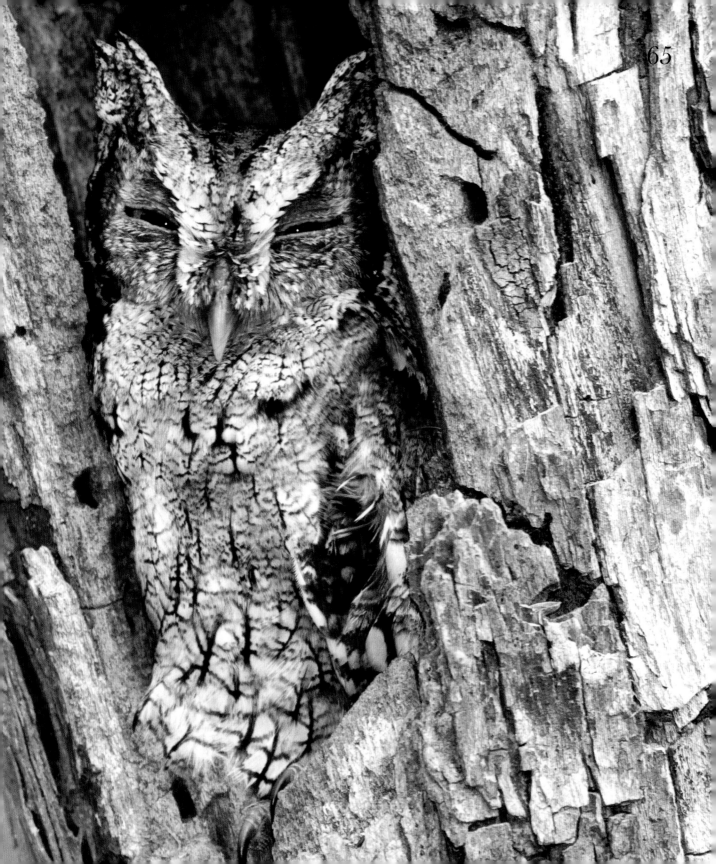

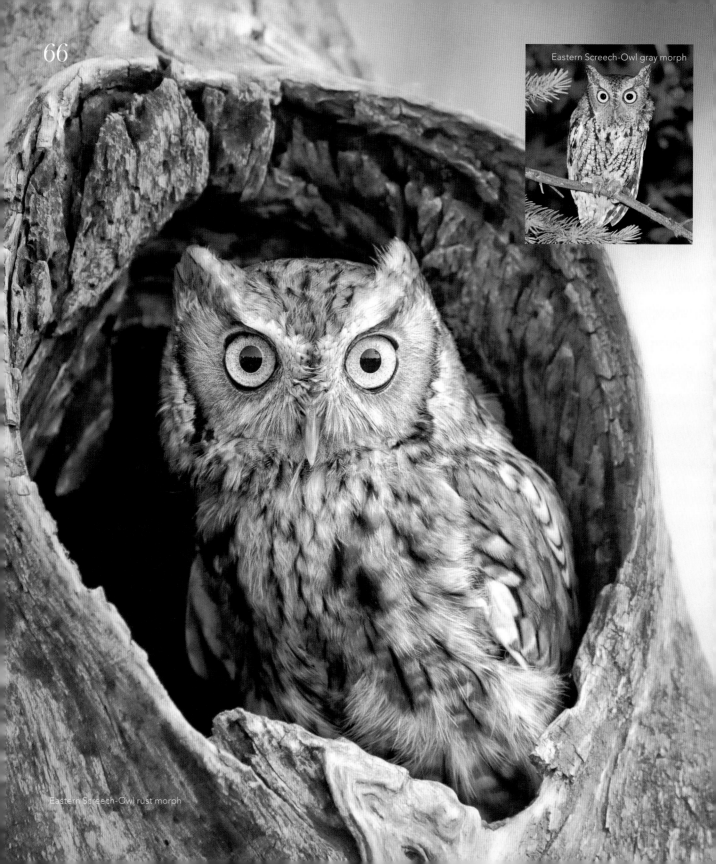

Eastern Screech-Owl gray morph

Eastern Screech-Owl rust morph

Color collections

A number of bird species occur in different colors, or morphs. Some hawk species, such as the Rough-legged Hawk, have a dark morph and a light morph. The condition of a species appearing in one of two color morphs is called dichromatism. Only three owl species in the United States and Canada are dichromatic—the Eastern Screech-Owl, the Northern Pygmy-Owl, and the Flammulated Owl.

Gray is considered to be the normal color morph of Eastern Screech-Owls. In fact, it is estimated that about 60–70% of this species is gray. Rusty colored Eastern Screech-Owls, called the red or rust morph, make up the remainder.

In 1833, German zoologist Wilhelm Gloger studied the relationship between color and habitat in birds and animals. He proposed Gloger's Rule, which states that more heavily pigmented birds and animals live in moist, shady habitats, while others with less pigment occur in drier, thinly vegetated environments. Although the range for both Eastern Screech-Owl morphs extends from the East coast to the Dakotas and down to Texas, the red morph is not evenly distributed. The farther West, the more this morph decreases. For example, in Florida, 70% of the species are red. In Tennessee, occurrence is at 55%. In Texas, at the western edge of the range, only 7% are red. The highest concentrations are in the Southern states that are east of the Appalachian Mountains, where 50–75% of the red population occurs. In Michigan and other Northern states, red morph populations comprise only 30%. Thus, Gloger's Rule applies well in this species.

Interestingly, the rusty red color may be more advantageous for camouflage in low-light conditions that occur in dense, deciduous woods or in cloudy, damp weather. This could be why the red morph is more concentrated in heavily forested, rainy areas and less so in sparsely timbered, sunny locations.

Fancy footwork

Among the many unique features of owls are their feet. Most birds have three toes pointing forward on each foot, with an additional toe, called the hallux, pointing back. Owls also have four toes on each of their feet, but only two face forward, one faces back, and one is reversible. The reversible toe can face forward or back, which sometimes results in what is known as a zygodactyl arrangement—two toes point forward and two point back. This alternative toe structure is shared with parrots, woodpeckers, and the Osprey, a fish-eating, eagle-like raptor.

Zygodactyl toes help owls grasp a perch after landing and may also help them capture and safely grip prey. This feature enables them to create a four-point, box-like pattern with the toes and talons of each foot, which maximizes the chances of catching prey. The Great Horned Owl uses its zygodactyl arrangement to create a talon spread that spans 31 square inches. That's like casting a large, sharply pointed net to snare prey.

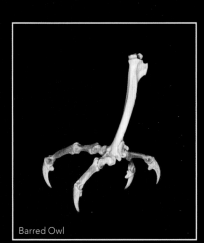

Barred Owl

Great Horned Owl

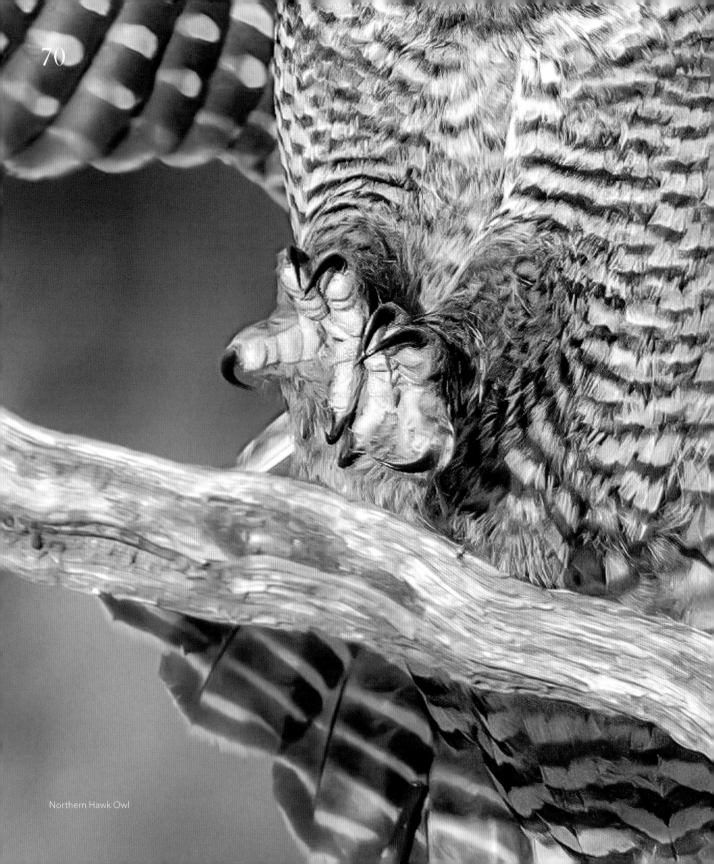

Northern Hawk Owl

Talons in force

Each toe of an owl is tipped with a large, curved, sharply pointed nail called a talon. All owls use their powerful feet and toes to capture prey, and deadly talons complement the job. Although talons are long and lethal, they are not often what dispatches prey. Owls use their talons to puncture the heart or other vital organs of prey, but more often an owl will simply ensnare prey with its talons, ensuring it doesn't squirm away before getting a fatal bite to the neck.

The size and shape of talons are directly related to the kind of food an owl hunts. Small insect-eating owls, such as the Elf Owl, have short talons on delicate small toes. The Snowy Owl and Great Horned Owl have large, extremely powerful feet with extra-long talons for hunting rabbits, hares, and other large animals that have the ability to fight back.

Sole scales

Owls also have very rough scales with tiny pointed spines on the bottom of their feet called spicules. Spicules help an owl hold onto slippery prey much like cleaning gloves with bumps help people grip slick objects. Spicules also help owls keep their grasp on branches, making it possible for many owl species to simply walk up strongly angled branches without having to fly.

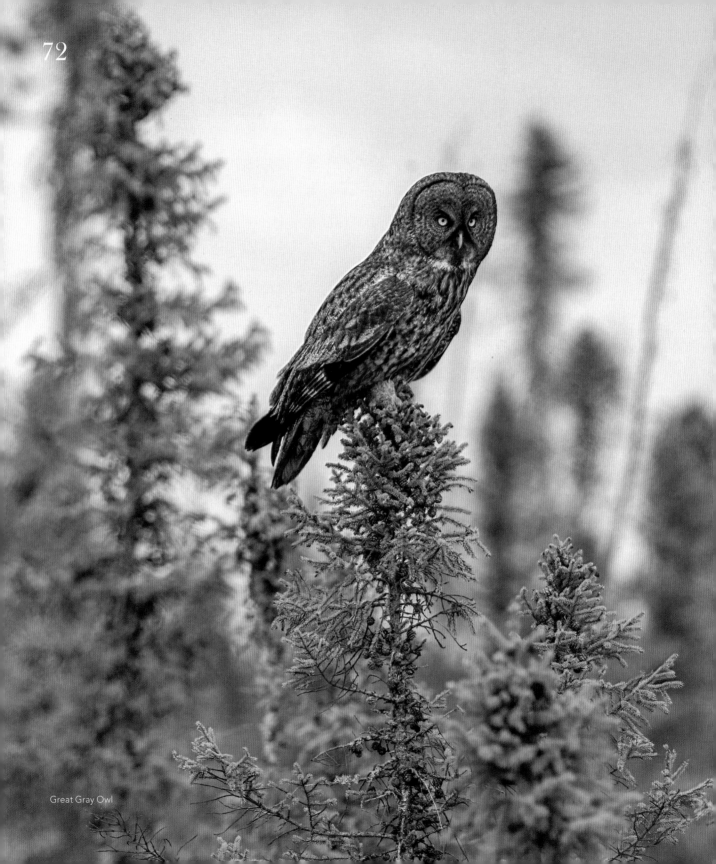

Great Gray Owl

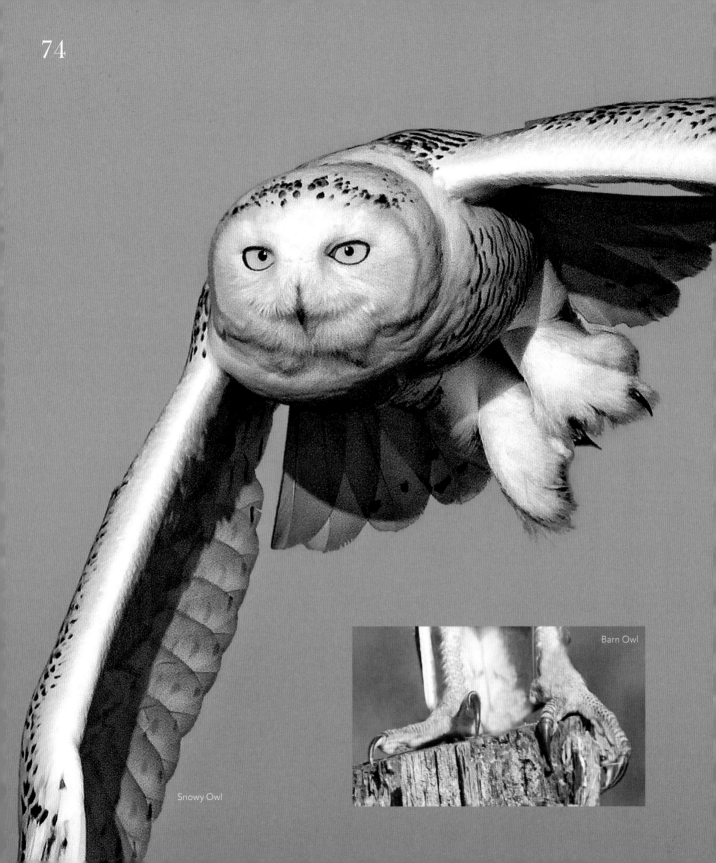

Barn Owl

Snowy Owl

Feather boots to bare feet

Owls that live in cold, Northern climates are dressed for the weather—their legs and feet are completely covered with feathers. Extra feathering keeps owls warmer during the winter and provides protection against bites from prey and other attacks. The Great Gray Owl, an occupant of Northern forests, has a dense layer of feathers covering its formidable legs and feet.

Insect-hunting owls residing in warmer climates have only slightly feathered, hairy-looking legs and feet. Since snagging an insect is much less hazardous than seizing other wildlife, hunting can be done barefoot. The Burrowing Owl has long, unprotected legs and feet to catch its main diet, insects.

Palate appeal

The majority of owls prey on small creatures, including rodents, birds, reptiles, amphibians, and insects. Most owl species eat a wide variety of these items, occasionally concentrating on one species when it is exceedingly abundant. While owls are generally opportunistic, feeding on whatever they can find and catch, the Northern Saw-whet Owl eats mainly mice, no matter the time of year. A Saw-whet will often catch a mouse during the night, return to its daytime roost, and stand on the prey until the following evening before dining.

The Eastern Screech-Owl has the most diverse diet of all US owls. Studies were first conducted in 1938 by A. C. Bent and later by Frederick R. Gehlbach in 1995. My own video studies of nesting and roosting Eastern Screech-Owls over a four-year period revealed that 100% of food intake during winter was small mammals and songbirds such as American Goldfinches and Black-capped Chickadees. During spring and summer, the diet was mainly june bugs, other large insects, and small mammals such as mice.

Great Horned Owls are not picky eaters either. They will hunt and kill a wide variety of small- to medium-size mammals such as rabbits and skunks. They also eat ducks, pheasants, and other assorted birds. In fact, Great Horned Owls are well known for killing and eating other owls.

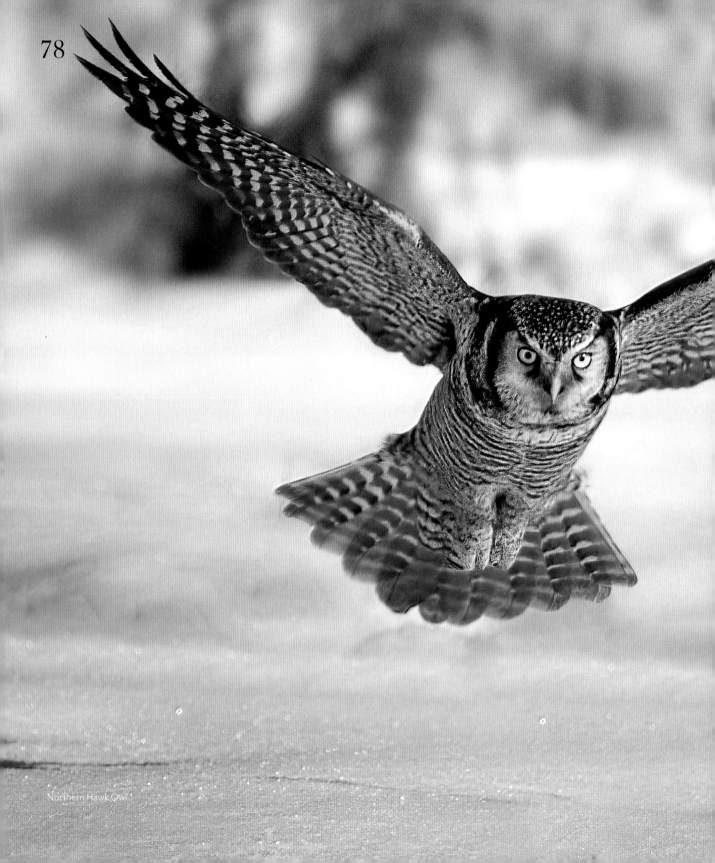

Northern Hawk Owl

Hunting instincts

The hunting instincts of owls, like those of cats, are triggered by movement. Most owls will just sit and watch a mouse that is not moving. However, the second the mouse flinches, the owl locks on and swoops in for the kill. Owls usually ignore carrion and roadkill because of the lack of movement. There are reports of owls feeding on roadkill, but this is the exception and not the rule.

A friend of the farmer

According to well-known ornithologist Paul A. Johnsgard, Barn Owls are good friends to farmers. Johnsgard determined that over the average 10-year life span of a typical Barn Owl, one owl will eat about 11,000 mice. Based on the amount of food one mouse eats in a day, each year Barn Owls prevent roughly 13 tons of grain and crops from being eaten by mice!

Table manners

Unlike hawks and eagles, owls usually don't tear up their food before eating. Instead, they swallow their prey whole. They ingest prey in one piece because their bills are comparatively shorter and weaker than those of hawks and eagles. Sometimes they remove the head of small rodents first. Owls also rip apart food items to feed to their babies. Great Horned Owls and other owl species swallow mice, birds, and other smaller foods intact, but they tear up larger prey, such as pheasants and rabbits, swallowing large chunks separately.

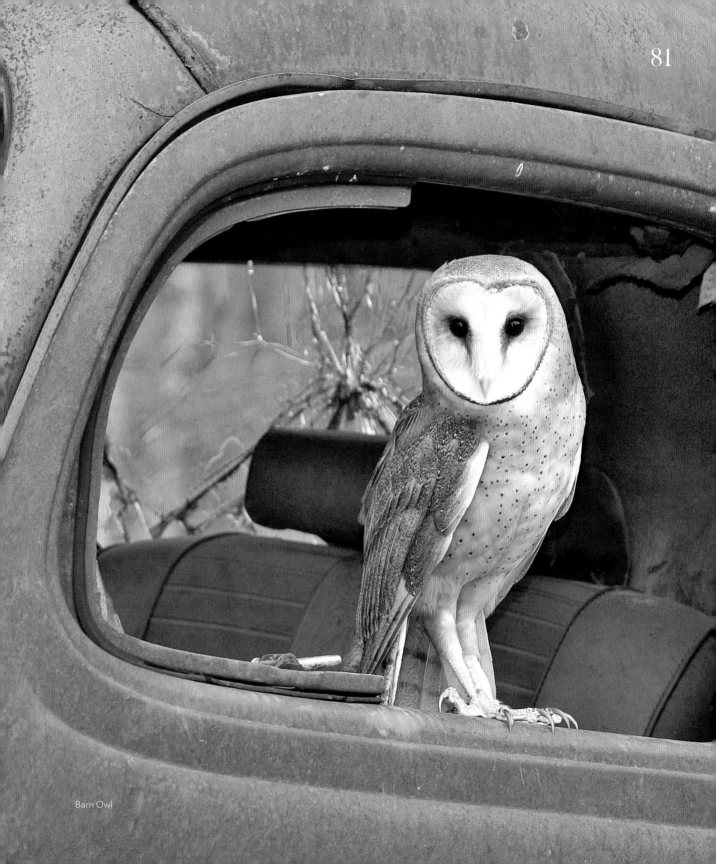

Barn Owl

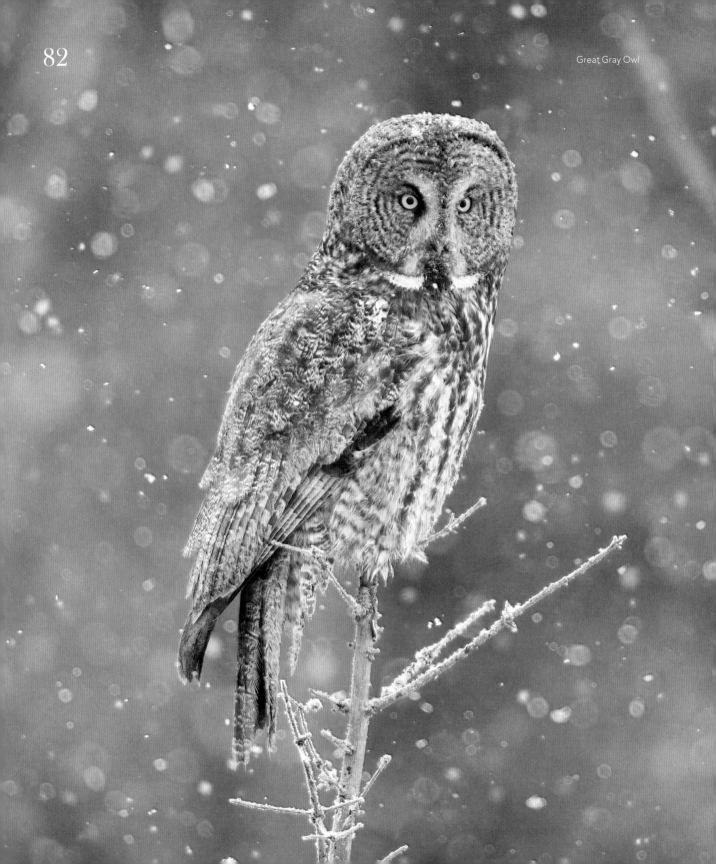

Diminished sense of smell

Like most birds, owls have a weak sense of smell or none at all. In most mammals, the ability to smell is directly linked to the number and quality of taste buds on the tongue. Since people have thousands of taste buds and most bird species have fewer than 100, it is presumed that birds have a significantly reduced ability to smell. Vultures and some other bird species depend on dead or rotting meat for food and have a well-developed sense of smell for finding food. Owls, on the other hand, rely on their keen hearing and outstanding eyesight to hunt for their meals.

Digestible matter

Owls have an unusual digestive system. Food passes through the mouth and into the esophagus—the tube leading to the stomach. Owl stomachs are unique because they have two chambers. The first is a glandular chamber at the top of the stomach. Called the proventriculus, this is where food enters and a mild acid and enzymes are secreted, beginning the digestive process.

The second chamber is known as the gizzard. This is a thick-walled, muscular compartment where food is churned and pulverized. Most digestible matter turns to liquid here and passes from the stomach into the small intestine. Fur, bones, and any other indigestible items left behind are compacted into a mass that the owl regurgitates back through the esophagus and out the mouth in what is called a pellet.

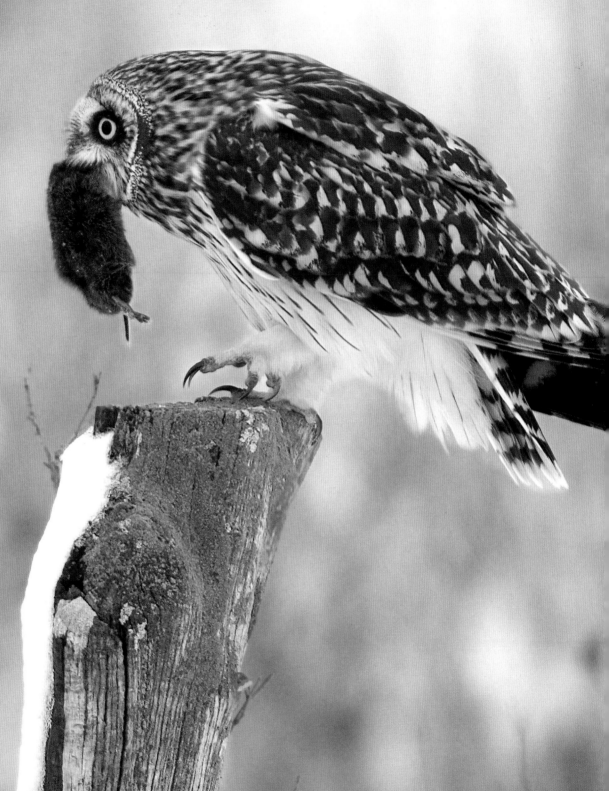

pellet

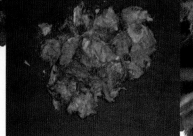

broken-up pellet

contents of pellet

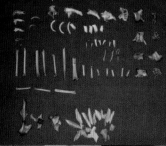

Pellets

Many bird species cough up undigested food in the form of pellets. Hawks, eagles, shrikes, crows, grebes, herons, and cormorants are just a few that produce them. Pellet production and content depends on the acidity of the stomach. The stomach acid of an owl is about pH 2.35, which is relatively weak. At this acidity level, bones and fur of a small mammal would not be digested. The stomach acid of hawks is around six times stronger, making it easier for most bones of the same animal to be digested, leaving only a small, watery fur pellet to regurgitate.

Pellets are well formed, tightly compact, and contain all the bones and fur that were not digested. They are interesting and invaluable for study, giving us a window into the gastric life of an owl. With enough skeletal remains, we can even identify the exact species an owl has devoured. Pellets also reveal how many prey items have been eaten in one sitting.

Most owls produce one pellet per meal, which often amounts to two pellets per day. Every meal is different and highly variable since dining depends on the availability of prey and the hunting skill of the owl. Larger meals take longer to make a pellet. Small meals are processed more quickly. On average, owls produce a pellet about 6–12 hours after eating.

Watching an owl produce a pellet is not a pretty sight. In fact, it looks like the bird is choking or experiencing some sort of convulsion! During regurgitation, an owl will writhe back and forth and usually lean forward just before opening its mouth to cough out the pellet, which falls to the ground.

Examining an owl pellet is fun and interesting. However, a word of caution—owl pellets can contain tapeworms and other parasites, as well as harmful salmonella, so handle them with care. Gloves and a face mask are always a good idea when handling and dissecting owl pellets. Pellets purchased through reputable companies are sterilized, odorless, and much safer for study.

Nesting fancies

Birds are well known for their nest-building abilities. Some species make nests strong enough to last for years. Others, such as Mourning Doves, put together a loose collection of about a dozen sticks. Baltimore Oriole nests are so intricately woven that they almost hold water. Hummingbirds use spider webs to bind their tiny nests and attach them to tree limbs. Woodpeckers excavate cavities in trees, while other birds, such as owls, don't make a nest at all.

Most owls in the United States do not construct their own nests. Some species take over existing nests, while others nest in cavities or on the ground. The exceptions are Burrowing Owls, which occasionally dig their own burrows for nests.

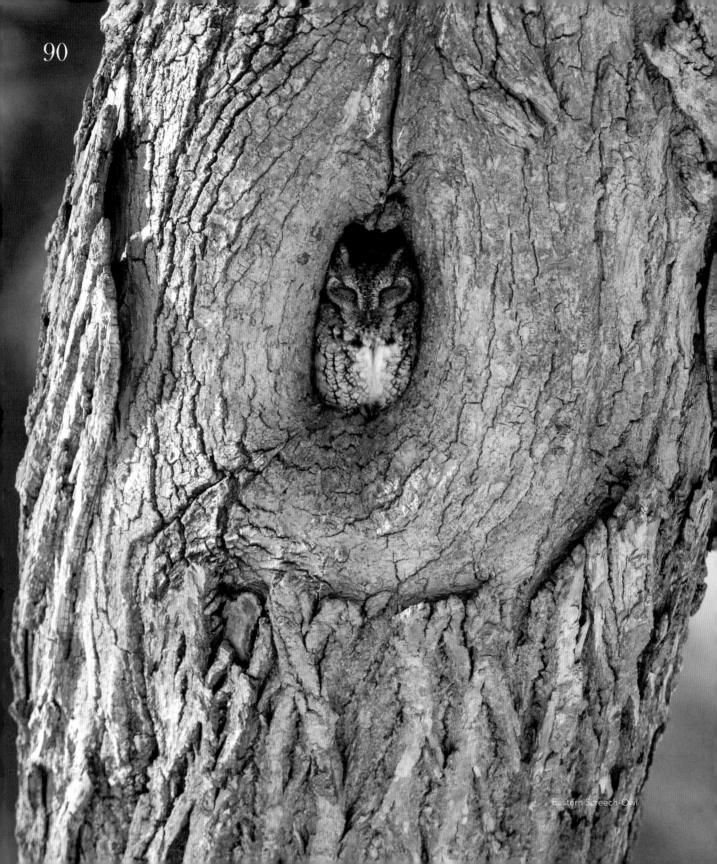

Eastern Screech-Owl

Cavity nests and stick nests

Many of our 19 owl species are cavity nesters. This means they nest in an empty cavity such as an old woodpecker hole or natural cavity in a tree trunk. Barred Owls use large natural cavities in mature trees for shelter and to raise their young. These nests are often more secure than other types, offering protection from both weather and predators.

Some small owl species, such as the screech-owl, nest in man-made wooden boxes in spring and roost in them during the day in winter. Often on cold, clear winter days, the occupant will sit in the opening to sun itself.

Great Horned Owls, Long-eared Owls, and others will simply take over the nests of birds such as Red-tailed Hawks, Great Blue Herons, and American Crows. Great Horned Owls nest before all other bird species each season, so they get the pick of all available nests. While they don't add nesting material or rearrange the structure, they will vigorously scratch the bottom interior of the nest before settling down to lay an egg.

Ground nests

Short-eared Owl and Snowy Owl nests are nothing more than a depression scraped deep enough in the ground to stop the eggs from rolling away. Short-eared Owls rely on their camouflage to hide in the surrounding grasses that help to conceal the site. Snowy Owls don't hide their ground nests since they are large enough to protect themselves and their young successfully most of the time.

Nest edifices

The Barn Owl nests in man-made sheltered places, such as barns and nest boxes, more readily than any other owl species. Before human settlement made outbuildings available, Barn Owls would nest in tree cavities, small caves, or rock wall depressions. Today, farmers and ranchers put up nest boxes for these birds because they are such great mousers, consuming hundreds of mice each year.

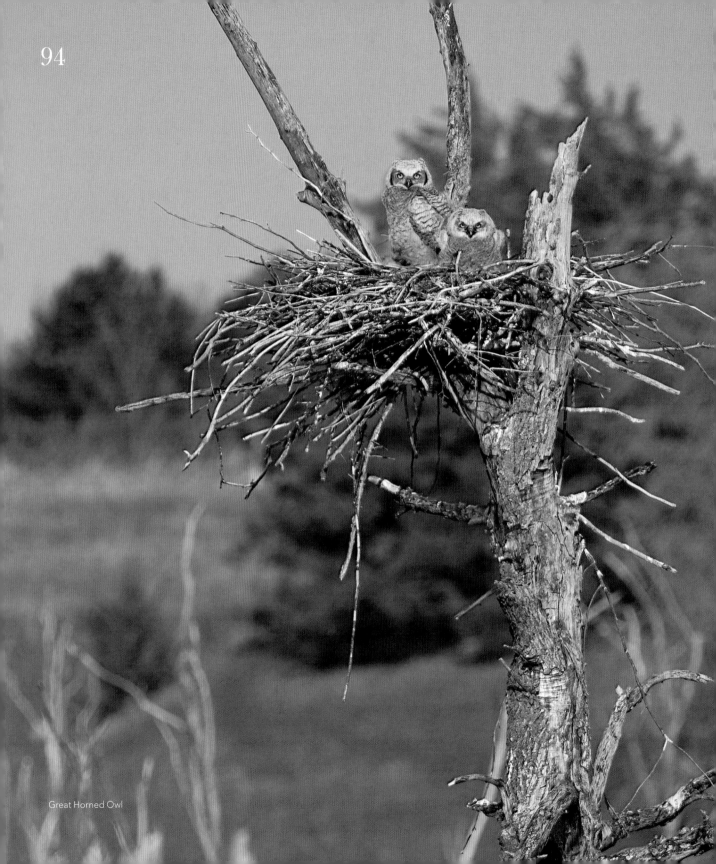

Great Horned Owl

Reusing the nest

More often than not, a nest site is used only once. However, owls will reuse a nest when the conditions are right. Sometimes a nest undergoes too much wear and tear and is unsuitable for reuse. A large stick nest used by Great Horned Owls, for example, may be in shambles after nesting season is over. Other nests are so sturdy that owls use them for several years.

Other times, nest reuse depends on the availability of suitable alternative nests. When there are many nest sites to choose from, owls may move around each year. Successful nesting is another factor, and successful nests are often used repeatedly. Barred Owls will usually nest in the same tree hole for many years, while Eastern Screech-Owls prefer to nest in the same nesting box or cavity from year to year. Barn Owls are famous for residing in the same nesting sites for generations. In fact, there are reports of Barn Owls using the same man-made structure for more than a century!

Owl vocalization

Of all the birds of prey, owls are by far the most vocal. Most can produce about a dozen different calls. Great Horned Owls, Barred Owls, and others can create so many different sounds that it's often hard to catalog all the variations. In fact, if you hear strange sounds repeated in the woods at night, they are most likely coming from a Barred Owl or Great Horned Owl.

Male owls tend to be the most vocal members of the family. Like all other male birds, they issue a unique call during the breeding season to proclaim ownership of a territory. Known as the advertising call, this call also claims a nest site, serves to intimidate other male owls nearby, and attracts females into the territory for courtship and potential mating.

Owls call for a number of other reasons. During breeding season, males scream and threaten intruding males during face-to-face territorial fights. They also have special calls reserved for the act of mating. There is a call to summon a mate for copulation and another, given by females just before mating, to beg for food.

Young owls are also extremely vocal. When the young are old enough, they give all sorts of calls, almost always when demanding food from their parents. These begging calls sound more like raspy hissing or screaming—not anything like the typical hooting calls of the adults.

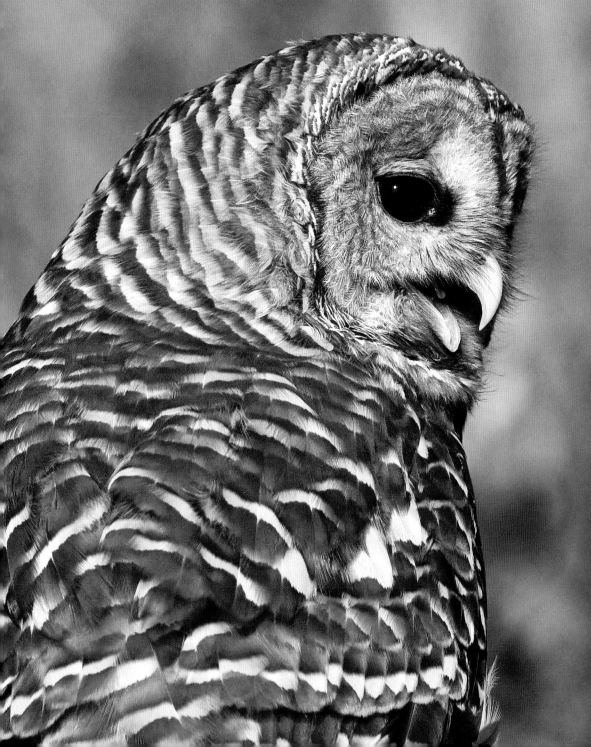

Northern Hawk Owl

Night calls

All owls start calling at twilight and extend their vocal activities into the night. Calling usually stops when hunting commences. Vocalization studies show that most owls call within a few hours of sunset and also just before dawn. They are often quiet late at night while hunting. Sky conditions, such as cloud cover, do not influence owl vocalizations, but rain and high winds tend to keep them silent. Barred Owls are well known for calling during the day. These calls are given to summon a mate to the nest.

Pair calls and duets

Most male advertising calls occur at the beginning of the breeding season and usually stop when the female starts incubating the eggs. Males stop calling so that they don't attract attention to the vulnerable female and her eggs while she is on the nest.

Females also have a full range of calls, but they tend to issue them less frequently. In many species, the male and female sing duets during the breeding season, usually with the male calling first, followed by the female. They will call back and forth like this for up to several hours.

Bill clacking

All owl species clack their bills together, creating a very loud, rapid snapping sound. This is an aggressive call that warns other owls and predators to stay away. Owls may repeat this call for up to several minutes. It is hard to mistake bill clacking for any other sound an owl makes.

Establishing a territory

Males usually set up a territory. Among cavity-nesting owls, such as the screech-owl, the male investigates several possible locations several weeks before breeding season. After settling in a territory, he will defend it and the nest cavities within it from all other birds. At night, he will often sit in the opening of his favorite cavity and call to attract a mate. A responding female decides if he is suitable for a mate and makes the final choice of the nest cavity. Since the female is larger, she must be sure she will fit comfortably in the space because she will spend the next month or more there, incubating the eggs and taking care of the young. The same process is true for Great Horned Owls and other owls that are not cavity nesters and that mate for life—the female chooses her long-term mate and also the nest that best suits her.

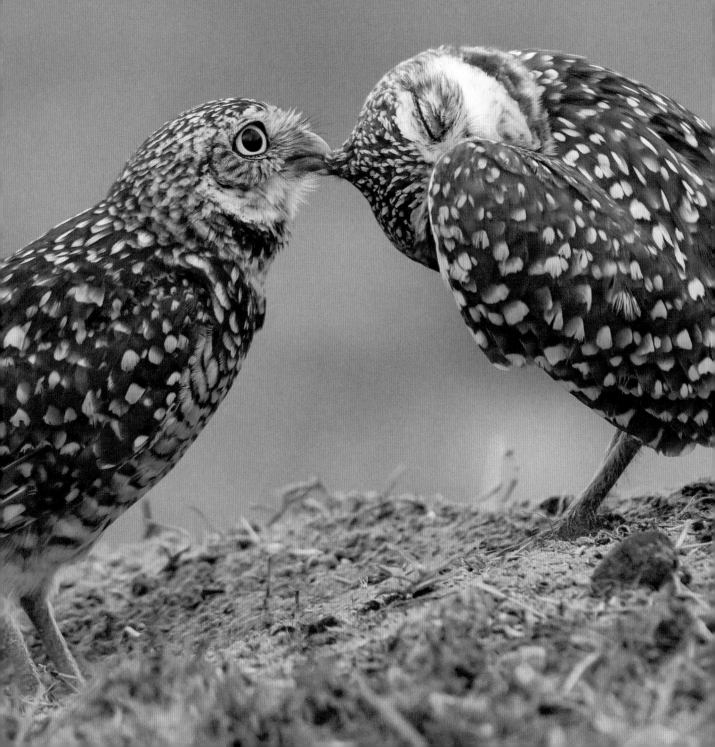

Courtship and mating

Owl courtship is one of the least understood aspects of an owl's life. It takes place in the dark and often in remote areas, so it has not been well documented by owl researchers. About a month or so before nesting begins, male owls start vocalizing. These calls serve to attract a new mate or renew the bonds of an existing relationship. In some species, males chase females, or vice versa. Chasing often concludes when the male brings the female a mouse or other food item, which shows he is a good provider.

As mating time approaches, owls engage in more calling, chasing, and food exchanges. When the pair settles down and sits together quietly, the time to mate is close at hand.

Owls will mate, or copulate, many times before the female starts to lay eggs. Copulation begins up to one month before egg laying, and it is not uncommon for it to occur dozens of times before any eggs are laid. The Barn Owl is the most energetic of owls, with pairs mating hundreds of times. Mating is a different affair for birds since they have no external sex organs. Both male and female birds have a single opening where the intestinal tract and reproductive tract merge. This opening is called the cloaca, or vent.

When owls and other birds mate, the male usually stands on the back of a crouched female. The male lowers his tail, the female lifts hers, and the two cloacae meet in what is called a cloacal kiss. During a brief 3-4 seconds, millions of sperm are passed from the male to the female. Sperm is stored in the female's reproductive tract for insemination of the eggs. It is usually the sperm from the mating event just before egg laying that inseminates. Thus, it is not well understood why owls copulate so much, which wastes energy.

Egg laying

Anywhere from hours to days or even weeks after mating, the female starts to lay eggs. Owls are the same as other birds when it comes to the frequency of egg production. Females produce one egg per day or one every other day. Each takes about 24–48 hours to develop and pass through the reproductive tract.

Every owl species lays nearly round eggs that are dull white and plain, lacking markings. Also, since female and male owls are both well equipped to defend and safeguard eggs, an eggshell disguise is not needed. In addition, many owl species nest inside dark cavities, making egg camouflage unnecessary.

Snowy Owls and Great Horned Owls produce the largest eggs, about the size and weight of those laid by domestic chickens. By contrast, an Elf Owl egg is approximately the size of a small cherry tomato.

The clutch

Unlike other species that often lay more eggs than they can incubate, the number of eggs an owl lays depends on its species. The Great Gray Owl, Great Horned Owl, Barred Owl, Spotted Owl, Elf Owl, and Flammulated Owl each lay two to three eggs. Barn Owls, Long-eared and Short-eared Owls, Eastern and Western Screech-Owls, Northern Saw-whet Owls, and Boreal Owls produce five eggs. Burrowing Owls, Northern Hawk Owls, and Snowy Owls lay the most—a total of seven eggs or more.

The number of eggs, or clutch size, an owl has depends on factors such as age and body size. In most species, the older and larger the female, the more eggs she lays. Egg production draws from the mother's body reserves, such as her bones for calcium. Mature, well-fed, healthy females lay larger eggs in larger quantities than those of young, malnourished, sickly females. Females near the end of life deteriorate in health, and egg production will also decline. In owl species that eat small rodents as their main diet, females lay more eggs in years with higher rodent populations and fewer eggs (or sometimes no eggs) during the years with lower populations.

Great Horned Owl

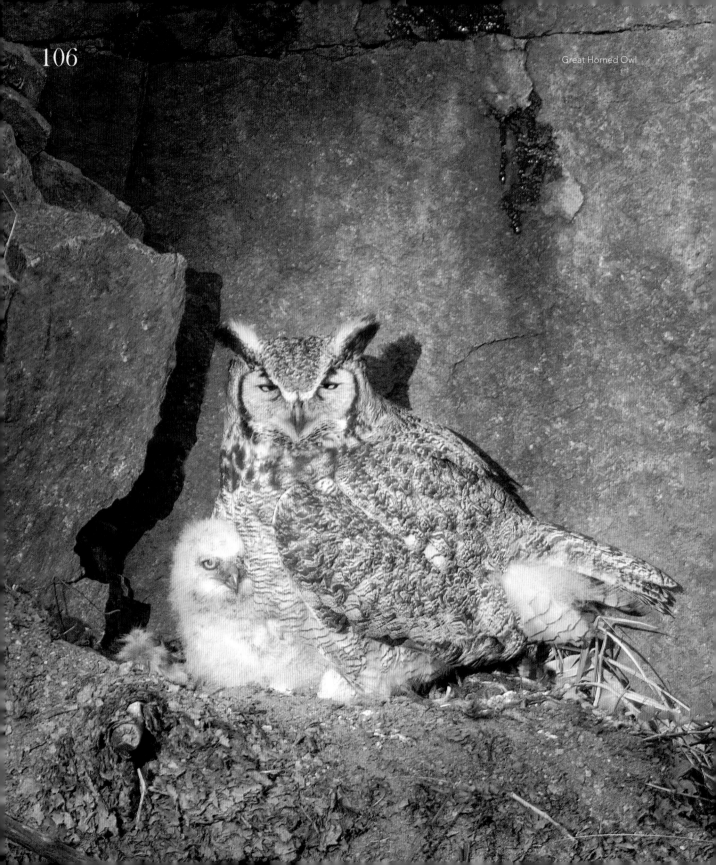

Nonstop incubation

In the world of owls, the female does the incubating. The male may sit on the nest or near it when the mother leaves for a break, but she is the primary incubator. Conversely, the male does all the hunting and brings food to his mate at the nest while she sits. In fact, the male may also feed the female for up to a month prior to egg laying and incubation. This is perhaps a bonding time for the pair and also ensures the male is fit enough to provide for the up-and-coming family.

Females sit on their eggs for over 23 hours a day, taking only infrequent, 5- to 20-minute breaks to defecate and stretch. An incubating female Great Horned Owl videotaped by the author supports this. The female incubated around the clock and sat for days, moving only occasionally to change position or go for a break. If people were to sit still for a month without moving around, our muscles would become so weak and atrophied that we would likely be unable to walk.

Hatching order

Once the female lays her first egg, she will start to incubate. This is unlike robins, cardinals, and most other songbirds that lay all of their eggs before beginning incubation. This results in all eggs hatching at the same time and is referred to as synchronous hatching. Since owls incubate eggs immediately after laying, each egg hatches at a different time. Called asynchronous hatching, the effect of this in owls is that chicks break out of their shells one to three days apart, resulting in owlets of different sizes.

The reason for asynchronous hatching has been debated for years. Some argue that since many owl species nest early in the year when air temperatures are cold, especially at night, they need to start incubating immediately to protect the egg from freezing, but that doesn't explain why owls nesting in warmer climates exhibit the same behavior. Others believe it is designed to help chicks survive after hatching. If a parent dies or food is deficient, older chicks will often kill and eat younger siblings to survive and to reduce the competition for food.

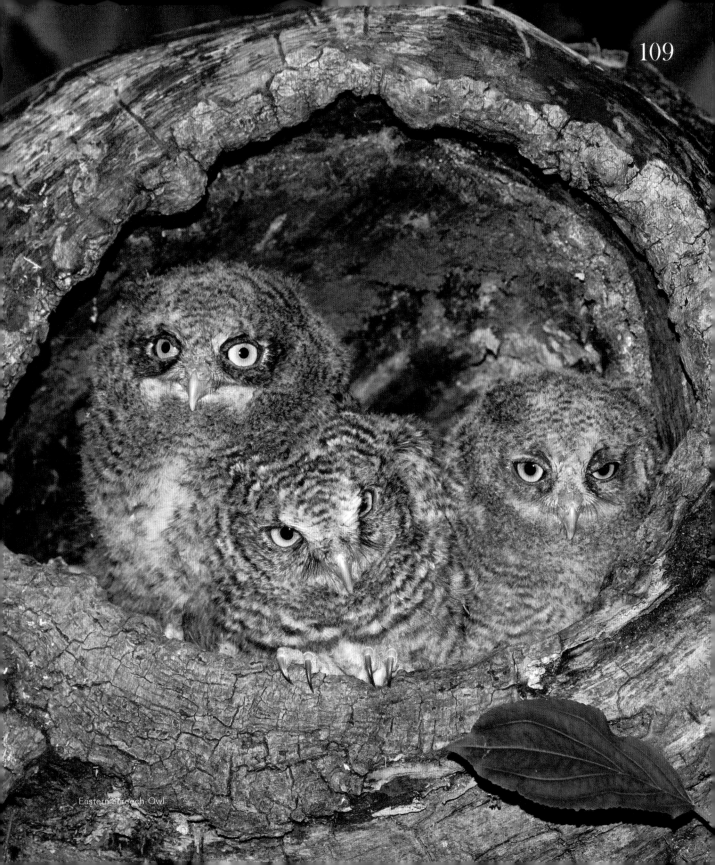

Eastern Screech-Owl

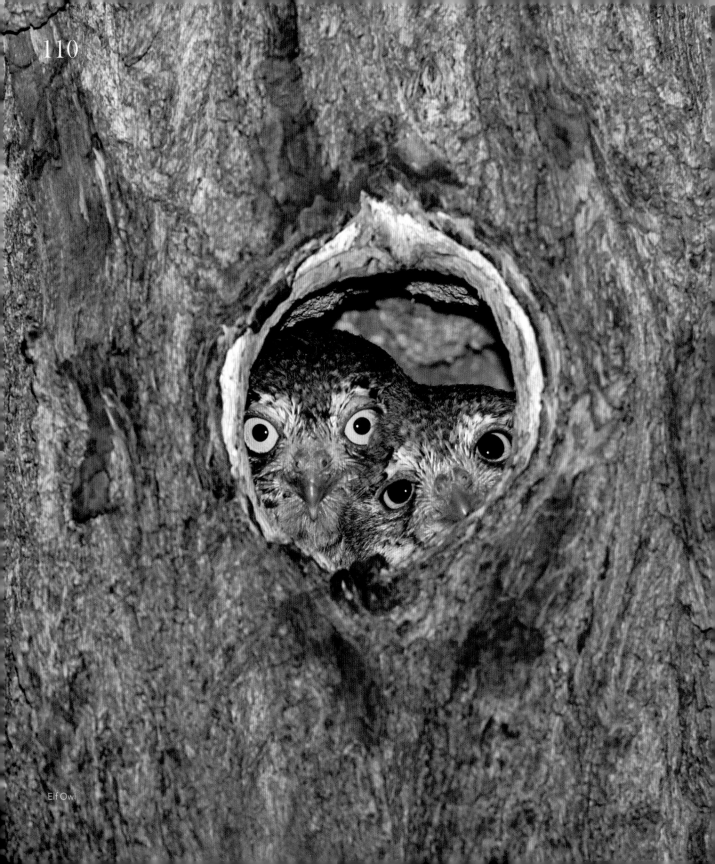

Elf Owl

Incubation across the species

The incubation period is roughly based on the size of the owl. Large owl species produce larger eggs, which take longer to incubate. Smaller owls produce smaller eggs and take a shorter amount of time to incubate. The incubation period of the Snowy Owl, the largest owl in the United States, is 32 days. The Elf Owl, the world's smallest owl, has a 24-day incubation. The first owlet to hatch emerges from the first egg laid. In another 24–48 hours the second owlet emerges from its egg, and so on.

Life in the nest

For 6-10 days, the mother owl will sit on her newly hatched owlets for most of the day and night to keep them warm. This stage, called brooding, is the source of the phrase "brooding mother." During this time the mother may take longer breaks than she did during incubation, but she still stays close to the nest and her offspring. The mechanism that regulates a young owl's body temperature has not developed yet, and the young cool quickly when left uncovered. If young owls cool off too much, they weaken and are unable to lift their heads to feed. When an owlet can't eat, it dies.

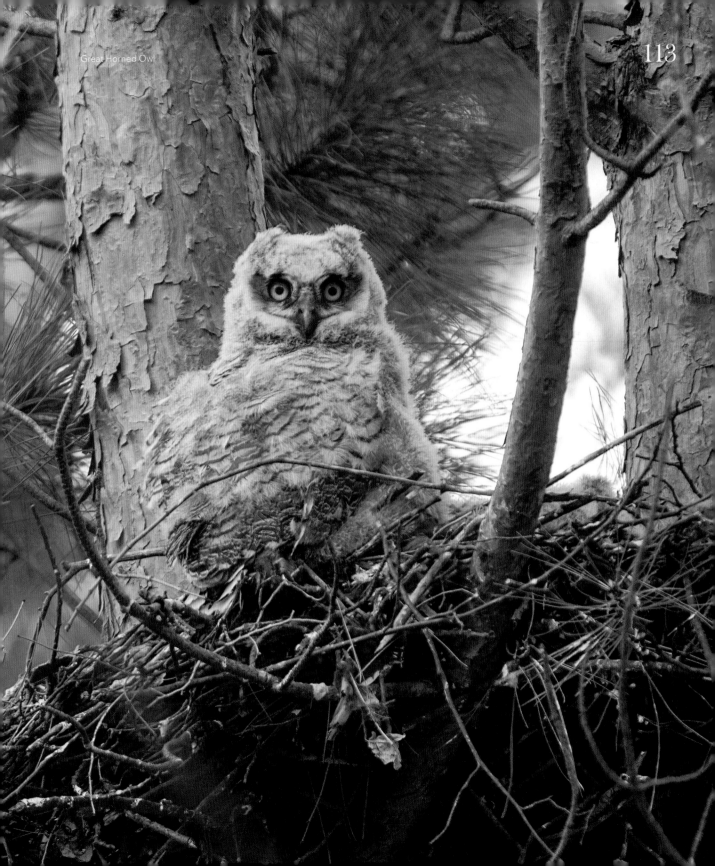

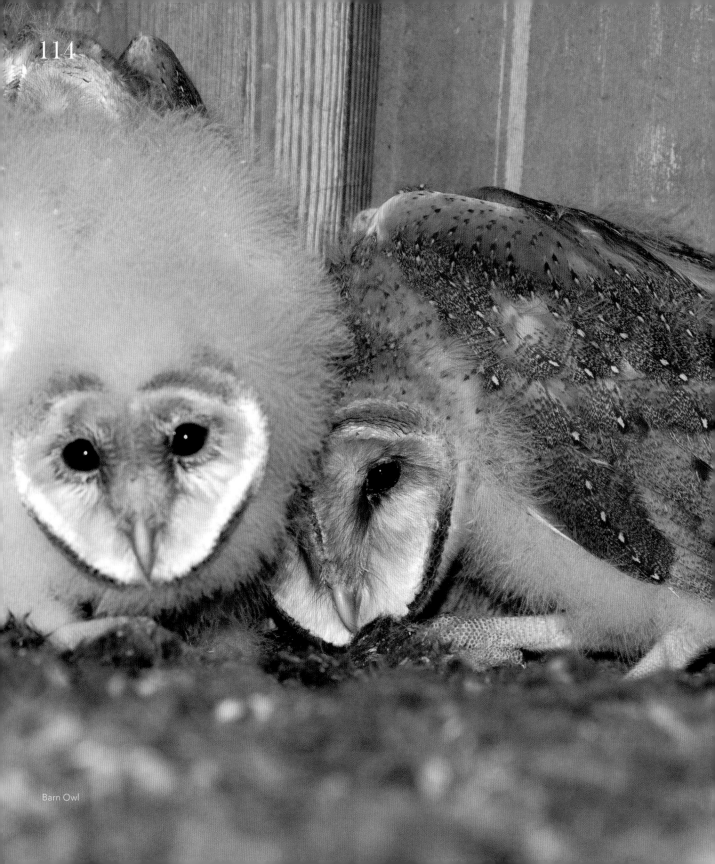

Barn Owl

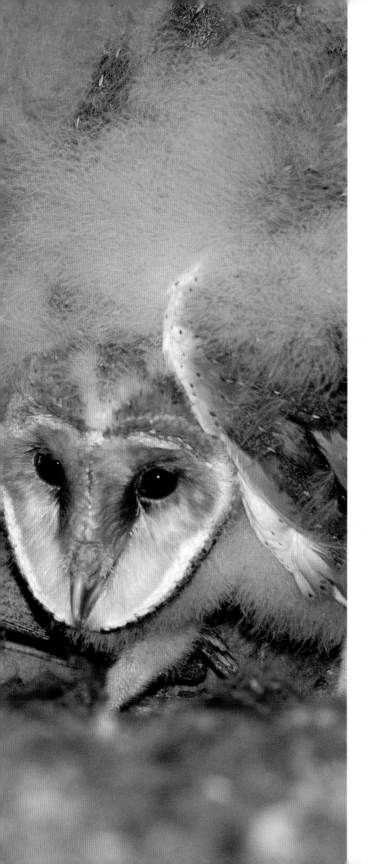

Growing up quickly

All newly hatched owlets are covered with a uniform coat of downy white feathers. They are weak, unable to stand, and can hardly lift their heads to beg for food. Their eyes are sealed shut until about 8-10 days of age. When their eyes first open, the iris is bluish gray. In yellow-eyed species, by the time the young leave the nest, their eyes have changed to bright yellow.

The amount and quantity of food brought to the young is the chief factor in their growth and development. When food is ample and nutritious, chicks grow quickly. Chicks lacking a steady supply of food develop more slowly and may even cease growing for a short period of time.

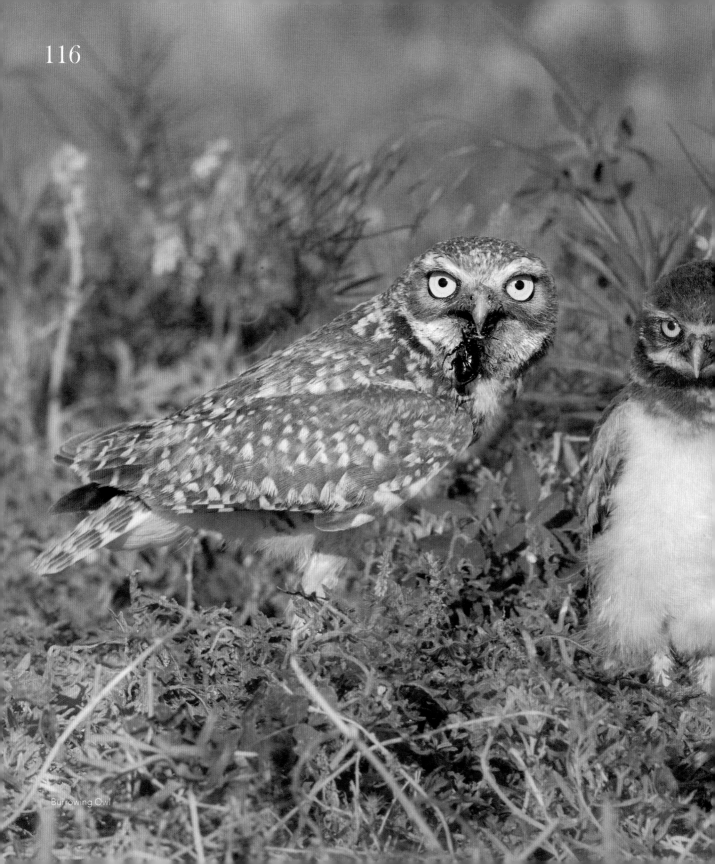

Burrowing Owl

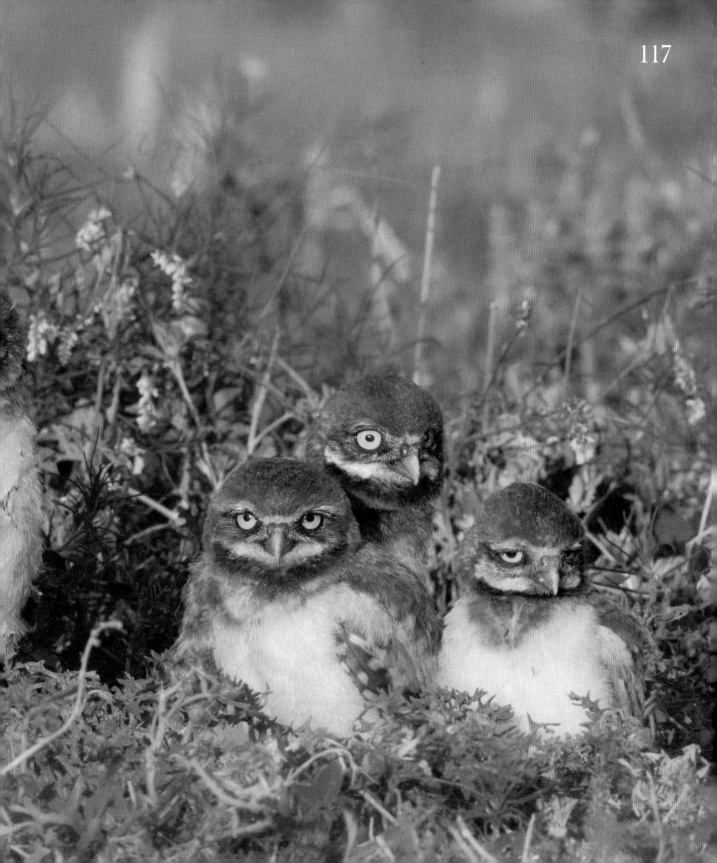

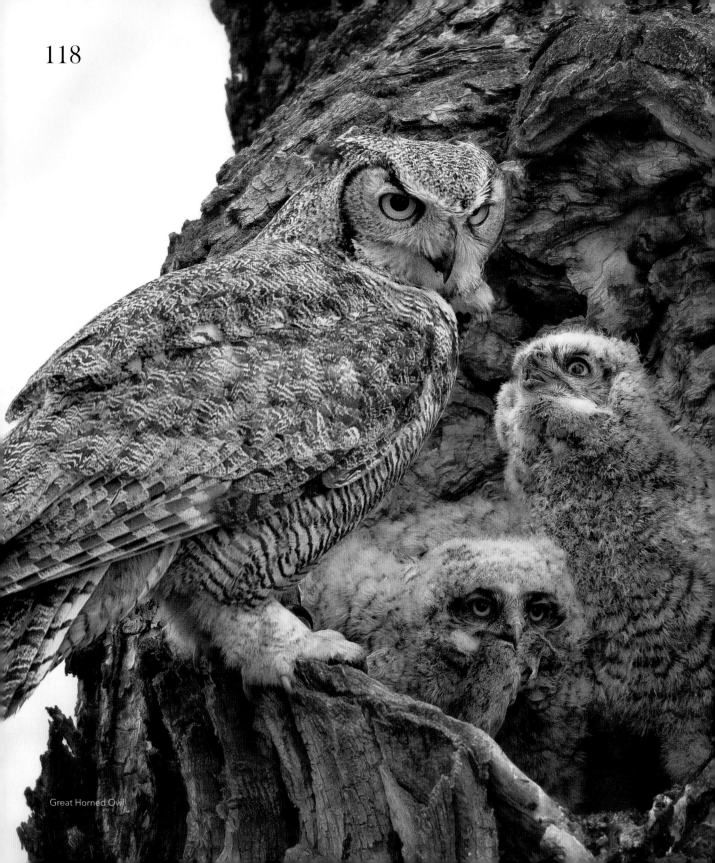

Great Horned Owl

Sharing in the bounty

The oldest or most aggressive of the owlets in a nest is the one who begs and gets fed the most. Only when this owlet is satisfied will the smaller and weaker siblings get a chance to eat. If food is limited, usually the youngest suffers and weakens. It is fairly common in all owl species for the older, stronger owlets to pick on the weaker one until it dies. As a means of survival, this often results in cannibalization of the youngest. This is also fairly common in eagles, herons, and other birds and is dependent on the available food source.

Demand for food

When owlets first hatch, the mother does all the feeding. The male does all the hunting and brings food to the mother. The demand for food jumps so dramatically when the young hatch that the male spends all his time searching for prey and providing food for his family.

When the male returns to the nest with food, many vocalizations take place. The female often begs for food as though she were a baby owl. After the male passes the prey to her, she tears it up and feeds each chick tiny morsels, being careful to avoid giving them bones and other indigestible parts. Occasionally she takes the food for herself or finishes up whatever the young owls haven't eaten. After feeding, the young often become drowsy and fall asleep. At that time the female settles down on the chicks again to keep them warm.

Owlet development

As the chicks get larger, there is less room in the nest for the mother. The female spends more time away from the nest, returning to feed the young only after the male has brought her some food. Once the young are large enough, she simply drops off the food at the nest before leaving, allowing the young to feed themselves. The male may also make food drops for the same purpose. In some species, such as the Eastern Screech-Owl and Barred Owl, males may occasionally feed the young directly at this stage of life.

When the chicks are about 2 weeks of age, they start to swallow food whole, bones and all. Their digestive tracts can now handle bones and fur, and they are able to cough up pellets containing the indigestible parts.

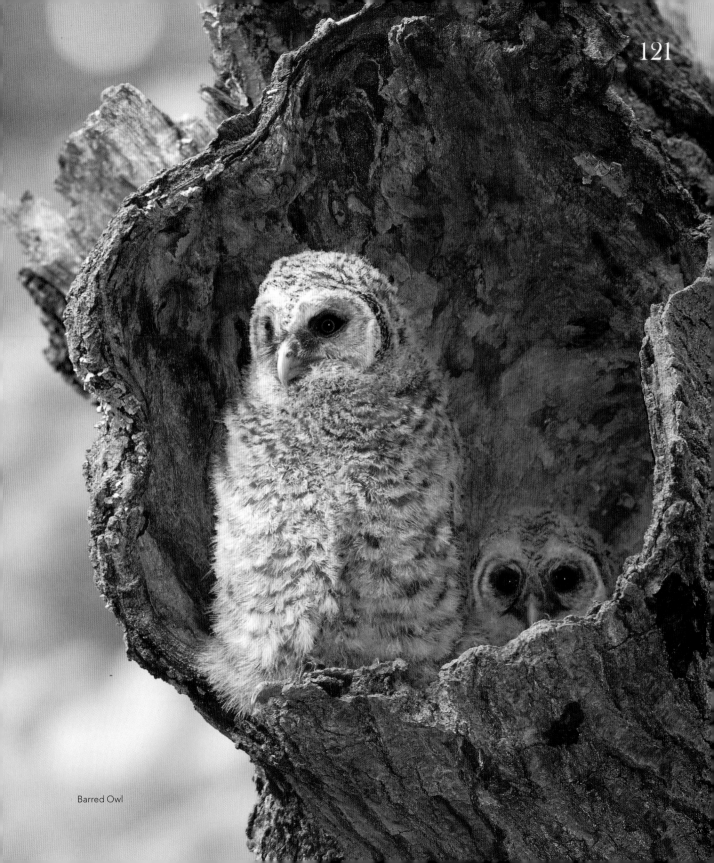

Barred Owl

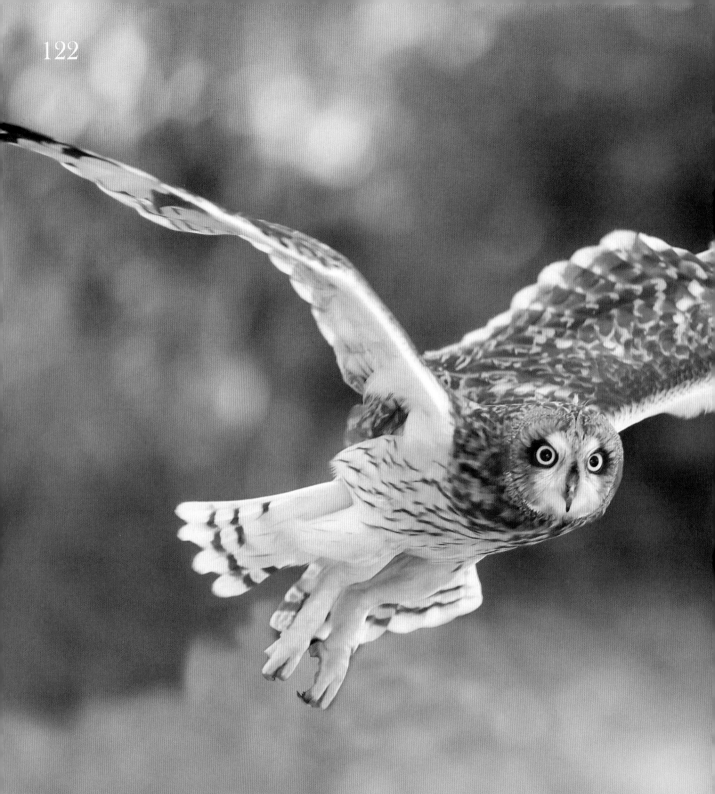

Short-eared Owl

Flight practice

Learning to fly is a major obstacle in a young owl's life. Once owls are ready to leave the safety of the nest, their life drastically changes. The time it takes to learn to fly depends on the nest type. Young owls from stick nests, or open nests, practice flapping their wings at the rim, building muscle strength. Cavity-nesting owlets have much less opportunity to stretch and practice. Young ground nesters learn to fly the slowest. They don't really need to fly since they can walk to and from the nest, with plenty of room to flap their wings.

Great Horned Owl young walk up and down branches while flapping their wings. They may even take short flights to nearby branches and can also return to their stick nest afterward. Owlets in cavity nests usually stay home longer than those from open nests. They are forced to fly right away since there are often no branches on which to climb. These owls take more time out of the nest to learn to fly than stick nesters and ground-nesting owls. The oldest leaves the cavity first, followed by the younger owls, each one to three days apart. They usually never return to the cavity after leaving it.

It is not uncommon for tree-dwelling owls to spend 24 hours to several days on the ground after leaving the nest. When an owl misses landing on a branch and ends up on the ground, it is often powerless to fly back up. Instead, it will huddle against a downed log or jump onto a short stump to seek safety.

Branching

Young owls that are leaving the nest often walk out onto tree branches. Known as branching, this is the time when the young move freely in the tree, going from branch to branch. When other trees are close by, the owls will walk the branches, moving from tree to tree.

Branching can last for several days to a week. After a day of exploring, young owls sometimes return to their nest each night. Most tree-dwelling owlets leave the nest at 4–6 weeks of age, depending on the species. At this time they are nearly the size of their parents, but their many downy feathers make it apparent they are youngsters.

Gliding and grounding

When young owls are learning to fly, they often begin by gliding from place to place. This usually occurs between 7–10 weeks of age, depending on the species. By this time both parents are bringing food to the young, who are often scattered around the nest site. However, no matter where the young may be, the parents can always find them to drop off food. While the young are spending time on the ground, they are more likely to be seen by people. Sometimes a well-intentioned person will pick up a grounded owl, thinking it needs help or is abandoned. Unless both parents are confirmed to be dead, young owls are receiving excellent parental care and will do just fine during their transition to flight. Their biggest threat is from domestic dogs and cats.

Barred Owl

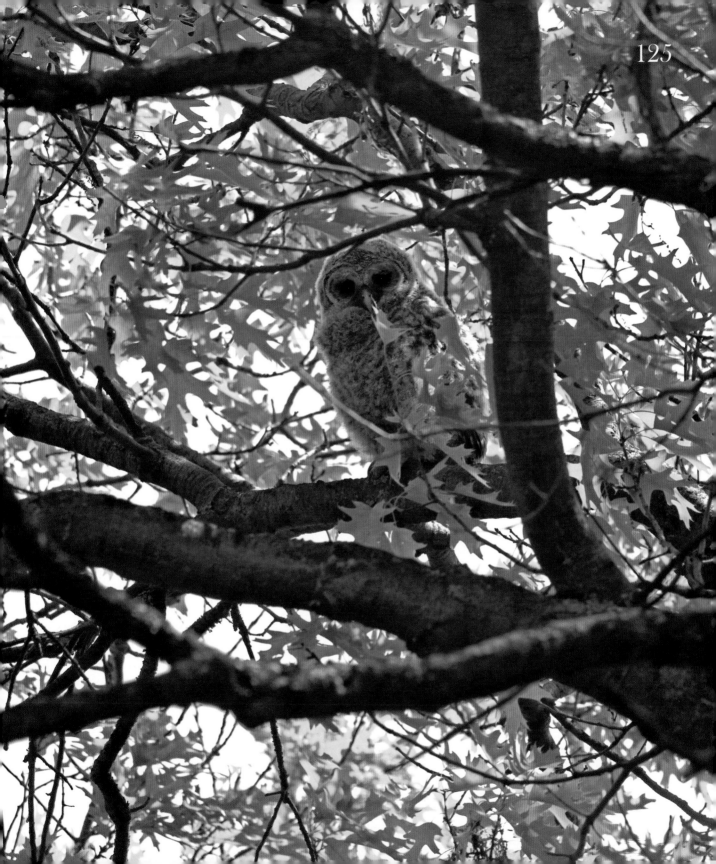

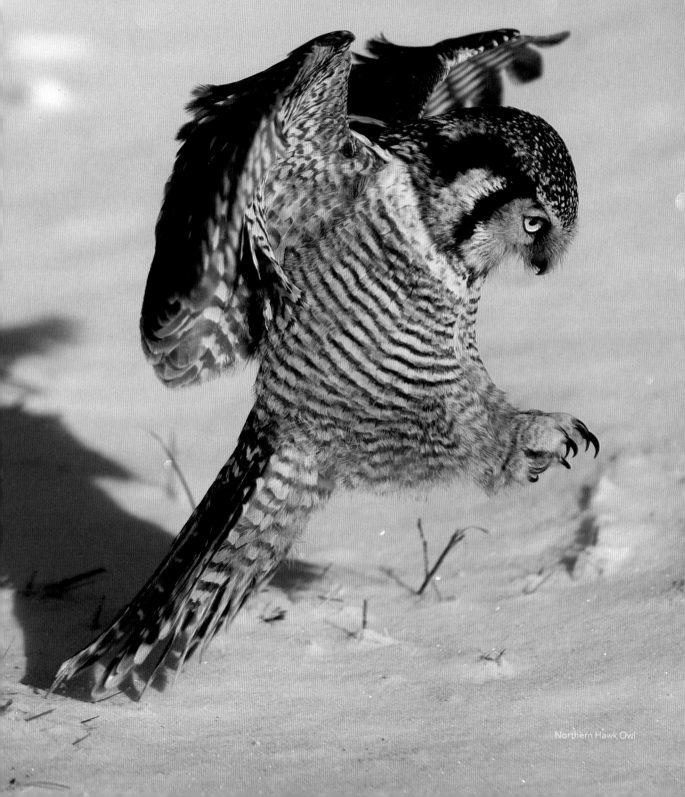

Northern Hawk Owl

Learning to hunt

During their first summer, the young remain with their parents. Slowly, over several weeks, the young become proficient at flying and start to follow their parents around to beg for food. This step of independence reverses the previous behavior of the parents having to find their young to feed them. In smaller owls that hunt mainly insects, parents feed their young for only a month while the young learn to hunt. In larger owls, such as the Great Horned Owl and Barred Owl, young take much longer to learn hunting skills. These young owls are fed for up to four months, usually until the end of their first summer.

At the end of summer, the parents gradually stop feeding their young. It is this time of year when teenage owlets can be heard begging to be fed. Just after dark the young begin calling for their parents to feed them. In Great Horned Owls, this sounds like a high-pitched screech or raspy hiss. This may go on for several hours until the youngsters realize they need to hunt for themselves. By the time winter starts, the young are fully able to hunt on their own. Meanwhile, their parents are preparing for another nesting season.

Leaving the natal territory

The time comes when young owls must leave the territory of their parents and make a life of their own. This event, called natal dispersal, usually occurs at the end of an owl's first summer up to early winter. Siblings often disperse at the same time, or not more than one to two weeks apart. Each youngster travels alone, usually going in a different direction from the others and seemingly without a predetermined destination. This is a very dangerous time for young owls since they must journey through unfamiliar territory to find food and shelter. Along the way, they will unwittingly enter other owl territories and encounter more perils such as cars, buildings, and power lines.

Owl parents do not drive their young out of their territory. Instead, natal dispersal is triggered by hormones in the adolescent owls. Some young owls disperse only short distances of up to 20–50 miles. Many others make marathon movements. Studies of banded owls have shown that some Long-eared Owl young travel over 1,500 miles to find their own territory, while some young Snowy Owls fly over 5,000 miles. The constant in young dispersal is that the oldest leaves first, followed by the next oldest, and so on. The oldest is usually the most healthy, fit, and has the most fat to make the rigorous flights necessary to establish a territory.

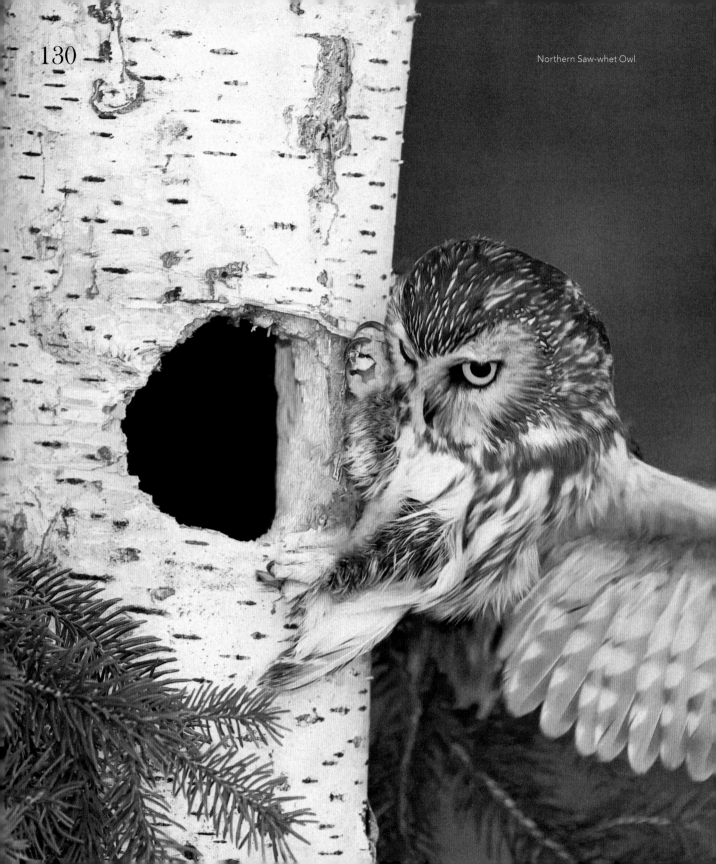

To migrate or not

Migration in owls is not really all that common. Of the 19 species that make their home in the United States, only the Northern Saw-whet Owl and Burrowing Owl are true migrators, moving with a predictable pattern at a set time of year. The Northern Saw-whet Owl is well known for its migration. Large numbers of these owls migrate consistently to regions south of their breeding range and return in the spring.

Six owl species are partial migrators. Partial migrators, such as the Long-eared Owl, move to various destinations when the local food supply dwindles due to weather changes. Only the owls in the northern limits of their range need to migrate. Others in the southern part of their range stay put because their food source is consistent. The remaining 11 species are nonmigratory.

The irruption years

Not all nonmigratory owls always stay in one place during the winter. In some years, usually when food supplies are low or when local populations of owls become exceedingly high, a percentage of an owl population moves out of its normal range in search of a reliable food source. These are called irruption years. The Great Gray Owl, Northern Hawk Owl, and others are well known for their irruptive behavior. Irruption can involve dozens to hundreds and sometimes thousands of owls moving into areas where they are not normally found. A classic example of irruptive behavior occurred during the winter of 2004–05, when thousands of Great Gray Owls and hundreds of Northern Hawk Owls moved out of Canada and into Minnesota. For those who were fortunate enough to see this natural event, it was a once-in-a-lifetime occasion.

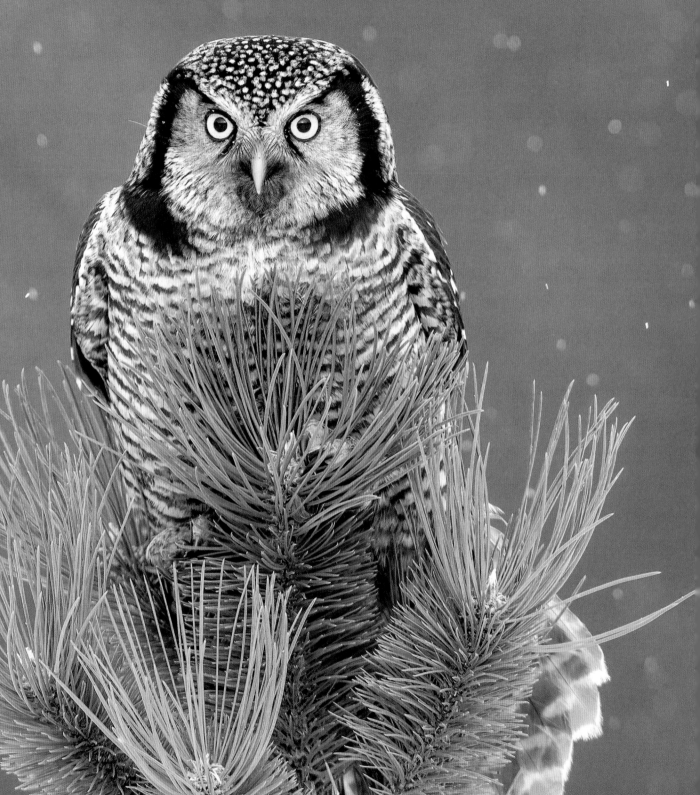

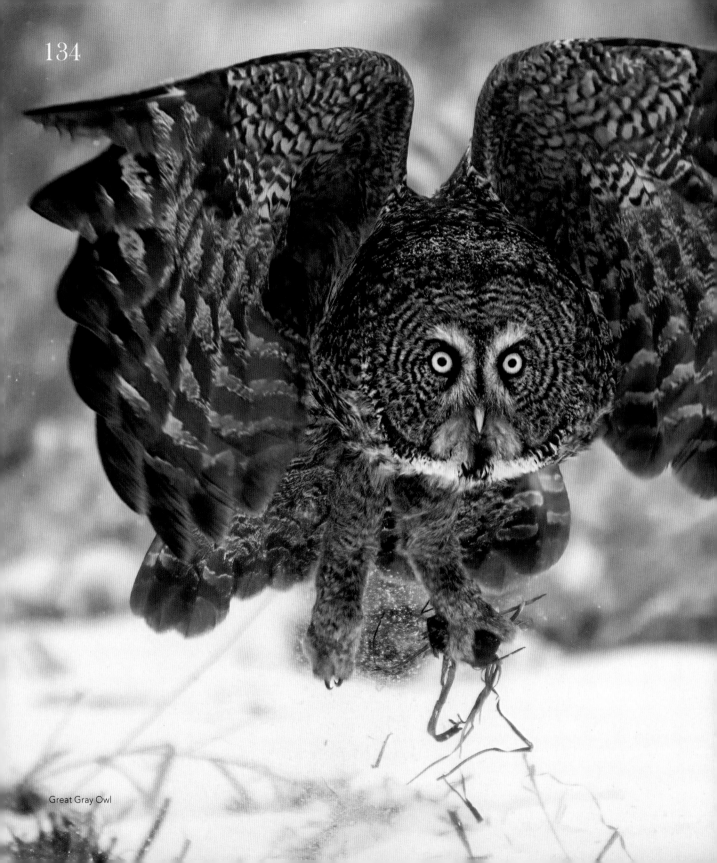

Great Gray Owl

Winter advantage

Winter may seem like a difficult time in an owl's life, but this is not necessarily so. Regions without cold, snowy winters present no advantages or disadvantages to owls. However, winter may, in fact, be an easier season for Northern owl species such as the Great Gray Owl and Great Horned Owl.

Several factors give a hunting advantage to these owls in winter. Longer nights provide more time to locate and capture prey. In addition, a shallow blanket of snow can give a mouse, vole, or shrew a false sense of security as it scurries under the cover. Since all Northern owls can hear prey moving under 12 inches of snow or more, they have little trouble punching through the crust to grab an unsuspecting critter. Finally, leafless trees help owls move around more easily in the woods and find more prey.

Owls— exceptional birds

Owls are a group of birds with such unique features and abilities that they can't help but capture the hearts and minds of those who see them. No matter where they are found, be it the frozen northlands, subtropical forests, or dry desert regions with sizzling heat, these creatures stand out as exceptional in the bird world. I would be happy to spend the rest of my days documenting these extraordinary birds through my photography and research. Maybe, if I am lucky, I will see you there in the field, also enjoying the intriguing owls.

Great Horned Owl

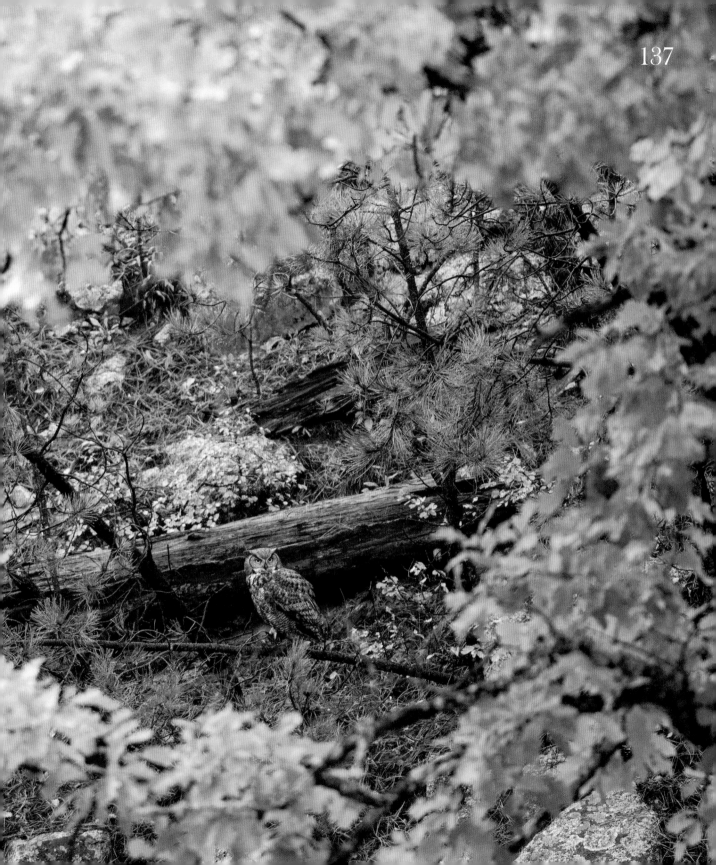

Featured owls

This photo spread shows all 19 owl species in the United States and Canada and their ranges. Maps do not indicate the number of owls in a given area (density) or the seasons in which you would most likely see them. Like other birds, owls move around freely and can be seen at different times of the year, both inside and outside their ranges.

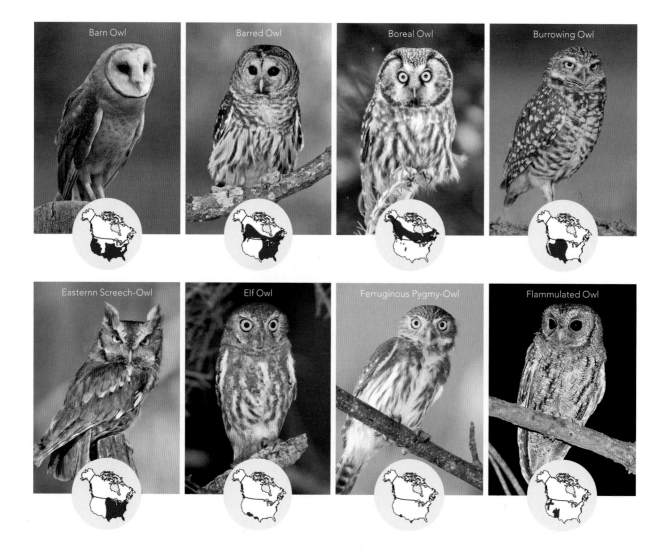

Barn Owl

Barred Owl

Boreal Owl

Burrowing Owl

Easternn Screech-Owl

Elf Owl

Ferruginous Pygmy-Owl

Flammulated Owl

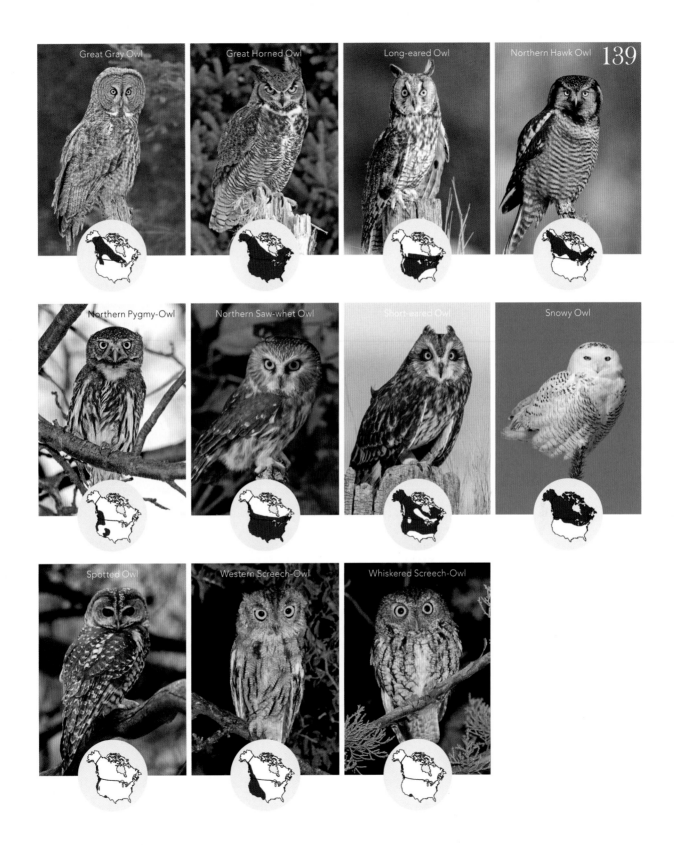

Great Gray Owl

Great Horned Owl

Long-eared Owl

Northern Hawk Owl

Northern Pygmy-Owl

Northern Saw-whet Owl

Short-eared Owl

Snowy Owl

Spotted Owl

Western Screech-Owl

Whiskered Screech-Owl

Activity at home: owl pellet dissection

Dissecting an owl pellet is a fun way to learn more about owls. This activity isn't just for kids. Adults really enjoy it, too, and will find it very educational. Owl pellets consist of the indigestible parts of an owl's food, and a pellet is regurgitated after every meal. These pellets mostly consist of hair, but they also contain bones, teeth, claws, bills, feathers, or even the exoskeletons of insects.

For owls that mostly eat small rodents, the entire skeleton of the rodent can be found inside a pellet. You can order pellets for dissection online and then try this activity at home. While the pellets you purchase are sterilized for your protection, it is still recommended that you wear gloves, a mask, and safety glasses while dissecting a pellet. Using small, pointed tools, such

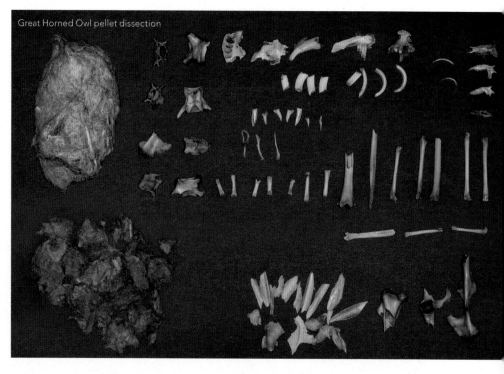

Great Horned Owl pellet dissection

as tweezers and toothpicks, will help you tease apart the pellet and reveal the tiny bones within. A small handheld magnifying lens is helpful because many of the bones are tiny and not easy to see. You can arrange the bones on a clean sheet of paper to help put the bones back together to discover what the owl has eaten.

Where to spot owls in the wild

Finding owls in the wild can be challenging. There are very few places where owls can be found reliably year after year. Here is a short list of places that are well known for owl sightings.

Olympic National Park, Washington State (Northern Pygmy Owl)

Sax-Zim Bog, Minnesota (Great Gray Owl, Northern Hawk Owl)

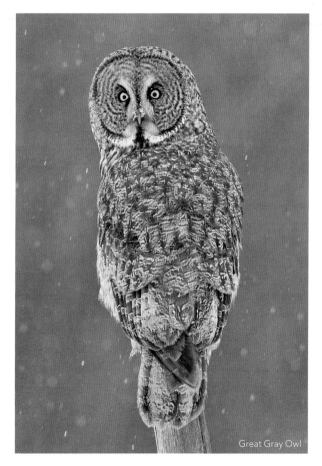

Great Gray Owl

Amherst Island, Ontario, Canada (Snowy Owl, Great Gray Owl, Northern Hawk Owl, Northern Saw-whet Owl)

Yellowstone and Grand Teton National Park, Wyoming (Great Gray Owl)

Northerly Island, Chicago, Illinois (Snowy Owl, in winter)

Jones Beach State Park, New York (Snowy Owl, in winter)

International Airports (Snowy Owls, in winter)

Many international airports in Northern states have viewing areas where it is safe to park, get out, and look for Snowy Owls.

Helpful resources

Cornell Lab of Ornithology Handbook of Bird Biology, Second Edition. Edited by Sandy Podulka, Ronald W. Rohrbaugh, Jr., and Rick Bonney. Princeton, NJ: Princeton University Press, 2004.

Manual of Ornithology: Avian Structure and Function. Proctor, Noble S. and Patrick J. Lynch. New Haven, CT: Yale University Press, 1998.

North American Owls: Biology and Natural History, Second Edition. Johnsgard, Paul A. Washington, DC: Smithsonian Institution, 2002.

Ornithology, Third Edition. Gill, Frank B. New York, NY: W. H. Freeman and Company, 2006.

Owls of the United States and Canada: A Complete Guide to Their Biology and Behavior. Lynch, Wayne. Baltimore, MD: The Johns Hopkins University Press, 2007.

Owls of the World: Their Lives, Behavior and Survival. Duncan, Dr. James R. Toronto, ON: Firefly Books, 2003.

Organizations that study and protect owls

Here are just a few of the many organizations that help study and protect owls. This is only a sampling, as there are many other organizations doing great work as well. A quick search online will reveal many more!

Owl Research Institute
www.owlresearchinstitute.org

International Owl Center
www.internationalowlcenter.org

Wild Bird Research
www.wildbirdresearch.org/owl-monitoring/

Snowy Owl Research
www.projectsnowstorm.org

About the author

Naturalist, wildlife photographer, and writer Stan Tekiela is the originator of the popular Wildlife Appreciation series that includes *Loons*. Stan has authored more than 190 educational books, including field guides, quick guides, nature books, children's books, and more, presenting many species of animals and plants.

With a Bachelor of Science degree in natural history from the University of Minnesota and as an active professional naturalist for more than 30 years, Stan studies and photographs wildlife throughout the United States and Canada. He has received national and regional awards for his books and photographs and is also a well-known columnist and radio personality. His syndicated column appears in more than 25 newspapers, and his wildlife programs are broadcast on a number of Midwest radio stations. You can follow Stan on Facebook, Instagram, and Twitter, or contact him via his website, naturesmart.com.